A–Z

OF

ELGIN

PLACES - PEOPLE - HISTORY

Jenny Main

AMBERLEY

Dedicated to those people, past and present,
who have helped to make Elgin such a special place.

First published 2019

Amberley Publishing
The Hill, Stroud, Gloucestershire, GL5 4EP
www.amberley-books.com

Copyright © Jenny Main, 2019

The right of Jenny Main to be identified as
the Author of this work has been asserted in
accordance with the Copyrights, Designs and
Patents Act 1988.

ISBN 978 1 4456 9211 1 (print)
ISBN 978 1 4456 9212 8 (ebook)

British Library Cataloguing in Publication Data.
A catalogue record for this book is available
from the British Library.

Typesetting by Aura Technology and Software
Services, India. Printed in Great Britain.

Contents

Introduction

Ancient man settled on this prime site beside the salmon river, where otters, kingfishers and red squirrels may still be seen. Great skeins of migrating wild geese fly overhead every autumn and spring, many overwintering on the nearby fields, but the remaining woods are no longer home to wild boar, beaver, wolves or bears.

Macbeth, the last of the Pictish kings, once ruled over this area and later, the building of the great cathedral gave the town its status. Merchants and craftsmen settled here and by 1296 Elgin, with a population of 800, became one of only four Scottish burghs.

By 1400 the city's population had doubled. The medieval market town was the agricultural centre of Moray county, and was affected by both of the Jacobite rebellions.

Land reforms took place and, having made fortunes overseas, men returned here to build charitable institutions and impressive houses.

New enterprises are now expanding. Productive farms surround the town while the university, long-established local businesses and the nearby Royal Air Force base all contribute towards this thriving community.

Elgin lost its city status during earlier boundary reorganisation but now, with more than 23,000 inhabitants, continues to develop and embrace new challenges.

A

Academy

The first school was attached to the cathedral in 1224 and the history of the Academy can be traced in a continuous line since then. In 1801 the Academy was originally situated on Academy Street, between Moray Street and Francis Place. By 1886 a new building with Doric portico was designed to accommodate 350 pupils.

The Academy was moved to larger grounds at Morriston in 1967 and the Moray Street building was modernised, opened in 1971 as the Technical College, before later becoming the Moray College of Further Education.

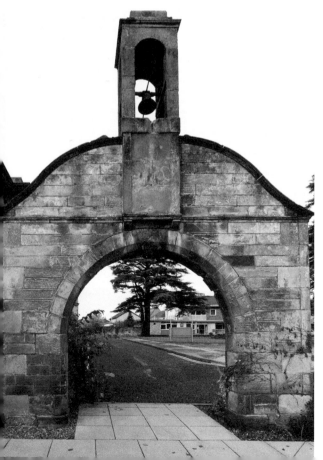

The original Academy gate.

The gateway with bell from the first building was re-erected in the grounds of the Moray Street establishment in 1906.

In 2006, after public consultation, proposals to amalgamate the Academy with the High School were rejected and, in 2012, a brand-new Academy building opened on the site at Morriston to accommodate over 1,000 pupils.

Alexander II (1214–49)

Elgin owes its early growth and development to King Alexander II, who, with his Queen Mari de Couci, visited the town several times. The Bishop of Moray was a great favourite of the pious king who obtained permission from the Pope to move the bishop's seat from Spynie to Elgin.

The king endowed Elgin Cathedral, founded the Greyfriars and the Blackfriars in Elgin, a hospice at Maison Dieu and nearby Pluscarden Priory. In 1235 he founded a chapel within Elgin Cathedral Church for the soul of his predecessor, King Duncan, who was mortally wounded by Macbeth near Pitgaveny and who died in Elgin in 1034. Alexander's last visit here was in 1244.

Allarburn Farm Shop

Allarburn dairy business in New Elgin once employed over sixty milk delivery people. The dairy was sold in 2007 and by 2013 the shop was enlarged and the local family-owned business now supplies local fresh farm produce. It also offers a large selection of delicatessen items and has a popular coffee shop offering locally made soups and snacks.

Major-General Andrew Anderson (1746–1824)

Prior to the Battle of Culloden, a regiment of Hanoverian soldiers were quartered at Elgin and one of them caught the eye of pretty local girl Marjorie Gilzean. Against the wishes of her parents they married and Marjorie followed her soldier on his travels abroad with his regiment. Three years later, widowed, destitute and distraught, with baby Andrew to care for, Marjorie made her way back home to Elgin. Her parents had died and she found her only shelter in the ruins of the chapter house of the cathedral. Local people were supportive and charitable and eventually Andrew obtained a 'pauper loon' funded place at the local grammar school.

Andrew did well at school, but an apprenticeship with a harsh uncle did not work out well and in 1760 he ran away to London, finding work in a tailor's shop. He eventually

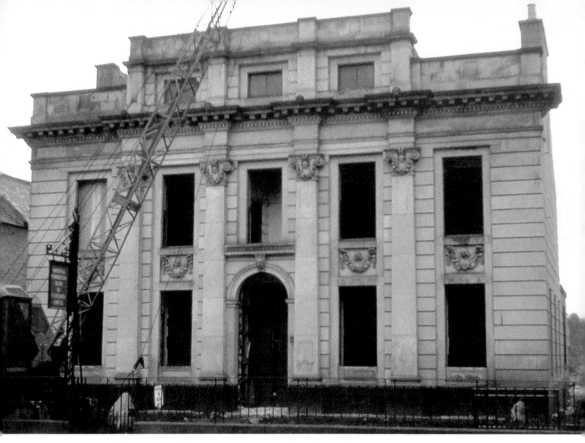

Demolition of No. 209 High Street, once General Anderson's home.

entered the army of the Honourable East India Company where his abilities and gift for languages resulted in promotion. He spent fifty years working in India, attaining the rank of Major-General and amassing a fortune before returning to Elgin in 1811 to live in a grand house at No. 209 High Street.

The house was later taken over by the Commercial Bank before being demolished and replaced by a mundane 1960s bank building.

General Anderson died in London in 1824, leaving a fortune for a charitable institution to be founded in Elgin.

Anderson's Institution

Funded by the generous bequest from General Andrew Anderson, the institute was 'for the support of Old Age and Education of Youth' (old age being considered as being over fifty-five!). Designed by the renowned architect Archibald Simpson, the building was opened in 1833. Accommodation was initially provided for ten aged and indigent pensioners, sixty children and for the establishment of a house governor, matron, teachers and servants.

In 1891 the Industry school at Anderson's was abolished and a board of twelve governors was elected. The free school was transferred to the burgh school board

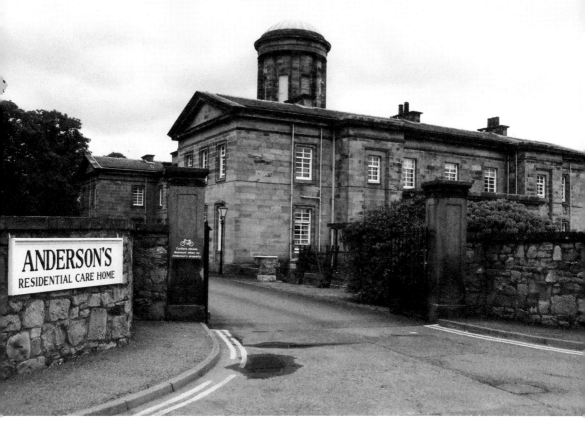

Anderson's Residential Care Home.

and became East End School, but children still boarded at Anderson's until after the Second World War.

Nowadays the Institute provides sanctuary and loving care to fifty-six frail and elderly residents.

Some of the massive ornamental stones carved by Thomas Goodwillie in 1853, for the Commercial Bank, once General Anderson's old home, were later discovered lying in a dump but were rescued and incorporated into the garden at Anderson's Care Home.

Andersons of Linkwood

During the reign of Charles II, an early member of this family was in the employ of the King's Advocate and, as a consequence of loyal service, was granted lands near Elgin.

Further generations became respected burghers, lawyers, sheriff-clerks and provosts. The family town mansion once stood where the County Buildings are now sited.

The Anderson family gravestone in the cathedral is 5 metres high and is the tallest in Scotland.

Barmuckity

From the Gaelic, meaning 'hill of pigs', the Moss of Barmuckity was once a small crofting community on the outskirts of Elgin, where a few cattle, sheep, cows, pigs and hens were kept on the seventeen smallholdings.

Despite being situated just a few yards away from the busy Aberdeen–Inverness main road, the crofters had no mains water supply and had to use buckets to collect water from a ditch to supply their families and their animals. In 1959 they successfully petitioned the water board for a domestic water supply.

Designated as a business park, development in 2018 at Barmuckity was delayed for a time due to the location of a water main.

Batchen

In 1800 John Batchen, an auctioneer, purchased Thunderton House. He feued the eastern part of the property and Batchen Street was formed, leading off the High Street. Like many other streets in the town it used to be cobbled.

Beer/Ale

There was once an extensive brewing industry within the burgh of Elgin with eighty private brewers in 1687. Records show that one innkeeper brewed 4,000 gallons of ale

Cathedral and old Brewery Bridge, 1910.

within three months, some for home demand, but a large quantity was exported to Holland, Norway and the Baltic ports. Following the Act of Union in 1707 an excessive tax on a pint of beer killed off this industry.

Bell, Alexander Graham

The father of Alexander Graham Bell was a professional elocutionist and headmaster at the now demolished Weston House Academy, Elgin. In 1864, at the age of sixteen, Alexander became an assistant teacher of elocution and music at Weston House.

Alexander is said to have developed the idea for the telephone while working in Elgin, telling his room-mate that he believed one day people would be able to speak to each other by telegraph.

Although he emigrated to Canada in 1870, he returned to this area in 1877, spending a week of his honeymoon at nearby Covesea.

Biblical Gardens

The first of their kind in Scotland, these gardens were made possible by the generosity of the local community and opened in 1996. Adjacent to the cathedral, the 3 acres contain many of the 110 plants that are mentioned in the Bible. School groups throughout Moray donated many of the trees and shrubs. A desert area depicts Mount Sinai and there is also a rock garden.

The central walkway is laid out in the form of a Celtic cross with areas of the garden depicting different stories, including Moses receiving the Ten Commandments, the Prodigal Son and Samson in the Temple.

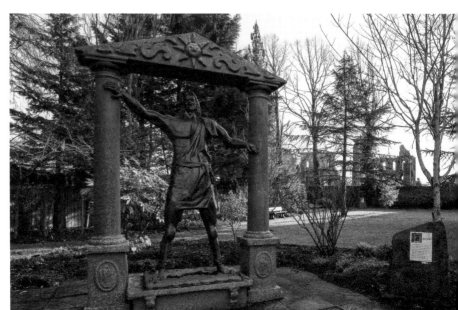

The Biblical Gardens in winter.

Bilbohall

Bilbohall lands and farm lay under the wooded knoll of Knockmasting. To the north were the Auchten part lands – sixty-four divisions of land distributed amongst the burgesses at a time when every freeman or burgess had to possess land. A new housing development now occupies Bilbohall Farm area.

Built at the west end of the town in 1835, Bilbohall Hospital was originally the Pauper Lunatic Asylum, and the earliest asylum built specifically for paupers in Scotland. Situated behind Gray's Hospital, it originally housed five inmates; by 1949 this had increased to 216 patients.

A long corridor with a stout, locked wooden door linked the asylum with Gray's Hospital. Upgrading and a three-storey extension in the 1970s brought the number of beds up to 161. By 1990 new facilities were developed, and eventually the old building was partly demolished and a new acute psychiatric ward created.

Bishops

The Bishopric of Moray was established in 1107 by Alexander I as part of the pacification of the north and lasted 581 years. The first bishop was a monk, Gregorious, who was based at Birnie and took over the Culdees system, changing it into the Roman-based system. For a short time, from 1187, the bishop's seat transferred to Kinneddar, then later to Spynie before the cathedral at Elgin was consecrated in 1224. Early bishops were a force for good, looking after the poor and needy, introducing education and culture, and inducing men of talent to live within the diocese.

Bishop David Murray, consecrated in 1299, was vociferous in his opposition to Edward I ('Hammer of the Scots'), and as supporter of Bruce was one of only three bishops present at his coronation. Edward instigated the bishop's excommunication but in 1313 Murray founded the Scots College in Paris. He is buried in the choir of Elgin Cathedral.

Many Elgin bishops played important and often vital roles in Scotland's political history, some traveling to Europe as ambassadors to negotiate treaties for the monarch.

The revolution and Reformation of the Church spelt the end of the, by then decadent, bishopric and by 1688 the last bishop, William Hay, was ejected, and the cathedral building began its long decline.

Bishopmill

In the distant past the small ridge of land overlooking Elgin was known as Frankolaw. A late Neolithic burial of a man with a bronze dagger and wrapped in ox-hide was found there many years ago.

William the Lion granted the lands to Richard, Bishop of Moray in 1187, and a flour mill was documented there around 1203. The mill, powered by the River Lossie, was driven by two wheels and was originally a flour mill, then a meal mill, and latterly a tweed mill.

The first mention of a village of 'Bisaptung' is in 1363 with a later charter of 1566 mentioning the 'Bishipos Mylne' and digging peats on the 'Laverock Moss alias the Bischopis Moss'.

By 1600 the miller was in constant trouble with the kirk session for operating on the Sabbath.

Having been in the possession of the Dunbar family, the estate was purchased by the Earl of Findlatter and laid out as a village in the late 1700s. A large granary was erected in the centre of Bishopmill in 1752, using stones taken from the ancient castle of Asleisk. The granary was later used as a school, then in 1869 converted into a mission church. It is now a plumbing business establishment.

By the end of the eighteenth century, changes in agriculture meant many cottars lost their land and moved into Elgin and Bishopmill to find work. The population was redistributed, new roads were built and by 1846 prosperous merchants and professional men were building desirable villas on the ridge of land facing south towards Elgin, overlooking the River Lossie.

Bishop's Palace

Despite the commonly used name, this was believed to be the Precentor's Manse. Additions were made to the building over the years – the south wing was added in 1557 and the finest room ornamented with a fresco ceiling.

After the Reformation the building was gifted by the Crown to Alexander Seaton, who was created Earl of Dunfermline in 1606. He added to the house, which was thereafter called Dunfermline House.

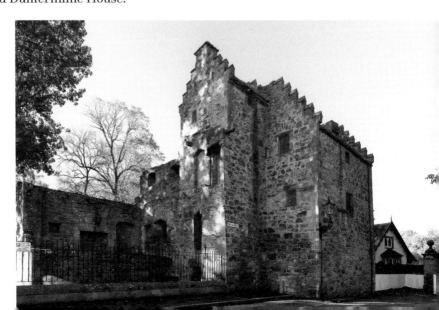

The Bishop's Palace.

When the 4th Earl was outlawed for fighting at the Battle of Killiecrankie, the estate fell to the Crown and was purchased in 1730 by the Duke of Gordon. The house was inhabited until the end of the century, then it was unroofed.

Eventually the property was purchased by the Seafield family and in 1851 the Earl of Seafield was dissuaded from demolishing the house by the museum directors. In 1884 the building and attached grounds were gifted to the town by the Dowager Countess of Seafield. The corbelled tower was reroofed with old slates taken from Thunderton House.

Blackfriars

The Dominican order of Black Friars was introduced to Elgin by Alexander II who is reputed to have met St Dominic, the founder of the order, in France during 1217. These were influential, zealous, preaching friars practising poverty and self-denial. They acquired substantial property in Elgin, enlarging their manor house, church and orchards.

Blackfriars Haugh lay north of Ladyhill. In 1750 the Blackfriars building and burying place was demolished and made arable ground. During this work many coins, rings, seals, and antique silver spoons were found, but were sold in Edinburgh and consequently lost. Tradition persists that people used the gravestones from Blackfriars when building their houses in Bishopmill.

During excavations for new houses in 1970, a large number of skeletons were discovered lying at random, with no evidence of coffin nails, leading to the theory that these had been plague victims who had been thrown into the monastery stank.

Borough Briggs

Briggs means small ridges of land, and describes the area once known as Westerhaugh, or 'Burrowbriggis', that existed before the River Lossie changed to its present course. Due to frequent flooding, it was recognised as unsuitable for building.

The large open ditch which ran from the upper part of town, across Borough Briggs and emptied into the Lossie was eventually converted into a covered drain in the 1820s.

In 1852 the council exchanged glebe land around the Furlin Yetts with 2 acres of ground at the east end of Borough Briggs belonging to the Earl of Seafield. It was to be used as a recreation ground in lieu of a right of way at the back of Grant Lodge.

Bow Brig

This was the first and the only stone bridge for 160 years over the Lossie. Finished in 1635, it opened up the roads between Elgin and Duffus, Drainie and Alves. The gradients were lowered in 1789 and the bridge survived the devastating flood of 1829.

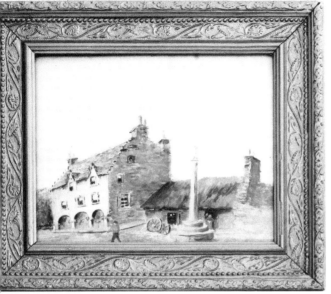

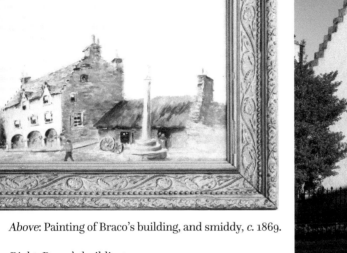

Above: Painting of Braco's building, and smiddy, *c.* 1869.

Right: Braco's building.

Braco's Banking House

At No. 8 High Street, this piazza building is dated 1694. Originally a dwelling house, between 1703 and 1722 it was turned into the bank and business house for William Duff of Dipple and Braco. William and his brother had profited from lending money during poor harvests, during the Darien scheme (1698–1700) and from forfeited estates during the Jacobite troubles.

His son, also William, continued in the business, determinedly acquiring as much property as possible. By 1735 the third William had become Lord Braco and commissioned William Adam to design Duff House, Banff. In 1759 he obtained an Irish peerage, becoming the Earl Fife.

Bruceland

Gallow Hill rises near Bruceland and the Glen Moray distillery site. As well as the site of public executions, this was also an area for public gathering and fairs, markets being held here six times a year in the sixteenth century.

In 1996 an ancient bronze axe-head was discovered here, as well as several medieval coins, artefacts and a few early nineteenth-century items. Some of the medieval items found in this area are now in the Elgin Museum.

Castle

Built on the site of an ancient fort, originally the centre of the town, the castle on the hill with its motte and bailey was mentioned in a charter of 1160. King William the Lion occasionally held court there, as did Alexander II, staying six times between 1221 and 1242, hunting in the neighbouring forests and spending Christmas at the castle in 1231. Alexander III also stayed in 1263.

When Edward I took up residence in 1296 to receive submission from the locals, the castle was recorded as being 250 feet long and 150 feet wide, enclosed by a thick, high wall which had towers and crenelated parapets. The well was situated within a round tower and was of great depth.

Edward's army of 30,000 foot soldiers and 5,000 horsemen camped around the castle and hill and those who came to make obeisance also brought a retinue. All needed feeding, resulting in a great strain on local resources. The wooden building of the castle was destroyed in 1297 and Edward was obliged to occupy a manse near the cathedral grounds on his next visit.

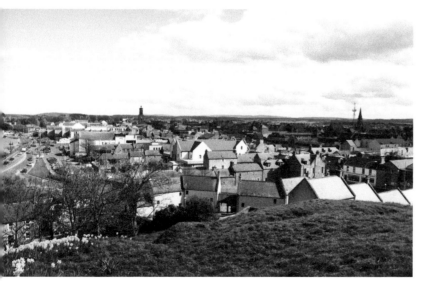

Above: Querns like this have been used for over 7,000 years.

Left: View from the castle ruins.

Legend tells of a blue haze or vapour hanging over the castle which so incensed the townsfolk that they rose in the night and buried the castle. Yet another legend tells of plague in the castle, explaining why the castle and its inmates were buried. Others suggest that a build-up of methane gas from sewage could have caused an explosion.

The castle was totally abandoned by 1455 but the stone keep and chapel dedicated to the Virgin Mary survived for over 150 years. In 1858 rough excavations uncovered flint arrowheads, pottery, a Charles II copper coin, a quern for grinding corn and three skeletons.

The superstitious tell of midnight voices coming from under the castle ruins, the noise of rocking cradles and nurses singing to soothe crying bairns.

Cathedral

Once the beating heart of Elgin, the cathedral developed from the old Culdee Holy Trinity Church.

The official cathedral dedication took place on 10 July 1224, on a brilliant summer's day, with a magnificent ceremony and procession with banners and great finery.

The building was aligned east to west, in the form of a cross with five towers – two at each end and one in the middle – with a great entrance gate at the west end.

A devastating attack by the notorious Wolf of Badenoch in 1390 resulted in many years of rebuilding. The massive 1-kilometre-long precinct walls were strengthened; only a small section now exists.

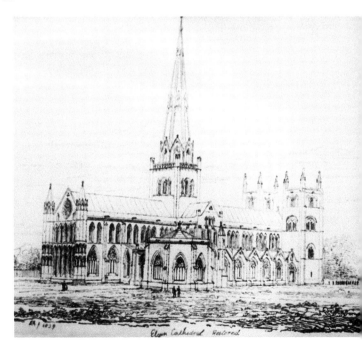

Elgin Cathedral.

The coloured glass in the windows came from Europe, flooding the building with light. Craftsmen were drawn to the area, skilled workmen came from all over Europe and some of their original mason's marks remain. Town houses were built for the gentry and Elgin became a seat of culture in the north, with more ecclesiastical buildings than anywhere in Scotland. The cathedral became known as 'the Lantern of the North' and at 289 feet long it was the third largest cathedral in Scotland.

The Chanonry was plundered by the Lord of the Isles, Alexander MacDonald, in 1402. Despite consequent excommunication, Alexander returned a few months later for more riches, but was met at the west gate, site of the Little Cross, by the bishop and clerics in full pontificals. A remorseful Alexander begged to be absolved of his sins, which was done with great ceremony – and the payment of a considerable sum of gold.

Repairs and rebuilding continued over the years. In 1505 the great steeple in the centre of the building collapsed and more rebuilding was required.

After the Reformation of 1560, the cathedral was never again used by Protestant or Episcopal bishops. In 1567 the order was given to strip the lead off the roof and it was sold to Amsterdam merchants, but was lost at sea.

In 1640 a fanatical minister and some local lairds destroyed medieval paintings and tore down the painted wooden rood screen, chopping it up for firewood. The destruction continued when, between 1651 and 1658, Oliver Cromwell's troops were lodged in the ruined building and mutilated statues and carvings. Some of their bullet marks remain.

On Easter Sunday 1711 the great mid-tower collapsed causing severe damage, but Catholics continued to secretly worship in the deteriorating building until 1714.

The massive site provided a convenient quarry for the people of Elgin until, in 1825, John Shanks was appointed keeper to look after the ruins.

As well as a Pictish carved stone and Scotland's tallest gravestone, the graveyard contains many interesting inscribed headstones, including the 1687 glover's gravestone which states

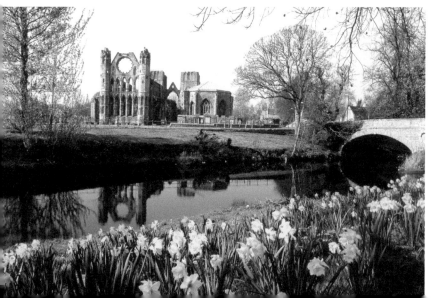

Cathedral beside the river.

'This world is a citie full of streets and death is the merkat that all men meets. If life were a thing that monie could buy, the poor could not live and the rich would not die.' There is also the grave of Patrick Sellar, the notorious factor of the Sutherland estates during the cruel Highland Clearances.

Today, Historic Scotland maintains the building and has opened an impressive, informative exhibition and access to the top of one of the towers, revealing a magnificent view across the surrounding area.

Cemetery

When the graveyard of the cathedral became overcrowded a new burial ground was opened in New Elgin in 1857, then extended, and the third part opened in 1907.

Across the road was an area known as 'Jeannie Shaw's woodie', where folk memory claims an eighteenth-century local woman would tend her cow. In the early twentieth century children would play among the trees, scrub, sandy ridges and gorse bushes. Local Brownies did their fieldcraft and nature studies there while, during the Second World War, soldiers from nearby Pinefield barracks would liaise with local girls in the 'woodie'.

A later extension to the cemetery was added in 1967 in this area and some local elders still refer to departed friends as being 'up in Jeannie Shaw's woodie'.

Chandler's Rise

This ridge of land running from Lesmurdie House once overlooked the great ancient sea loch of Spynie. When the pristine site was scheduled for housing development archaeologists rushed in. Their finds included over 1,000 Mesolithic arrowheads, early Neolithic bowls (4000–3600 BC), burial urns, a unique type of pot, evidence of Bronze Age burials and a ring ditch. It was concluded that this was once a highly important domestic site as well as a classic ritual site which had hitherto remined undiscovered.

Development was inexorable; houses now cover the great ring ditch and area of ritual cremations and burials, preventing further investigations into evidence of early inhabitants of 7,000 years ago. The importance of this site overlooking the town had not previously been realised and excavations were sadly limited by time and money before the arrival of the bulldozers in 2002.

Churches

The many church buildings in Elgin, some no longer in use for worship, testify to a complex history. Between 1563 and 1688 in Scotland there was a great struggle for

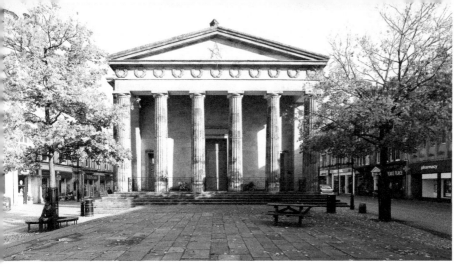

Entrance
to St Giles
Church.

ascendency between Presbyterians and Episcopalians. Bishops presided over synods during Episcopal times while later Presbyterians held an annual General Assembly.

The Church of Scotland was established in 1690 but eventually many parishioners objected to the power of the local laird to appoint a minister – a system open to corruption. In 1843, at the General Assembly of the Church, 474 ministers resigned on principle, giving up their homes and stipends to form a new Free Kirk.

Within two years over 500 new churches had been built with support of enthusiastic congregations. In Elgin a charismatic Dr Topp was soon preaching to a congregation of 1,200 in his new United Free Church on the corner of South Street and North Guildry Street. Joining with the Church of Scotland in 1929, it is now known as 'Elgin High'.

St Giles, once known as the 'Muckle Kirk', stands in the centre of Elgin on a site that has been in use for hundreds of years, long before the cathedral was built. With the need for enlargement, St Columba's Church in Moss street was built in 1906 as a daughter church for St Giles.

Other churches may be seen around the town, only a few still used as originally intended, but there are several alternative denominations of worship in use, including a discreet mosque.

Civil War

The townsfolk of Elgin were not spared the horrors of the English Civil War. Most supported the parliamentary side against Charles I and when troops representing the king occupied the area in 1645–46 buildings were burnt and lands destroyed.

Closes

As the medieval population of the town increased, wealthier merchants and burgesses lived in large houses that faced the High Street. Rows of thatched cottages were built at right-angles to the High Street, behind the larger houses, creating narrow alleyways

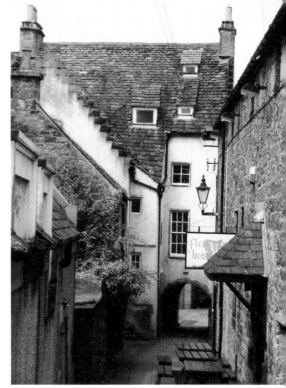

Above: Shepherd's Close.

Right: Shepherd's Close restored.

called closes, usually with ten cottages in each close. These closes survived well into the nineteenth century and were often named after the families that lived in them, or after a trade.

In the mid-nineteenth century poor families lived crowded together, up to ten people in one or two rooms. They shared one outdoor toilet in each close, taking a candle to light the way on dark nights, avoiding the dogs, stepping over rubbish heaps and around pigsties.

Despite the ban for safety reasons in 1735, many of the cottages continued to have thatched roofs, and many closes remained paved with cobbles until the mid-twentieth century.

Poverty and disease ran rampant in these crowded conditions but there was often a strong sense of community, with tolerance and even fondness for some of the odd 'characters', and a few people did manage to escape the desperate poverty to achieve a good degree of education and work skills.

College

The ancient precinct of the Cathedral College was enclosed by a boundary wall 'six and a half feet wide and four yards high'. This wall enclosed the Cathedral College – six manses with their grounds, gardens and orchards. A paved street ran around the wall, leading to four entrances, or ports. A small part of the wall remains near the bishop's house. After the 1560 Reformation, the manses were occupied as private dwellings before gradually being removed.

Cooper Park

The park was a private gift to the town by Sir George A. Cooper in 1902 and was opened to the public on 19 August 1903 with great ceremony. The previous town park was originally a small area at Borough Briggs, bought from the Seafield family in 1888.

In its early days, sheep were allowed to graze in the park, creating a nuisance in the bandstand and porch of Grant Lodge.

In 1909 the pond was frozen to a depth of several inches and the local newspaper recorded that skating was safely enjoyed by many people over a weekend in January before the ice melted.

The pavilion was opened in 1910, facing the cricket pitch. The boating pond was originally intended as a skating rink, boating not being introduced until 1923.

A First World War tank was displayed in the park from 1919 but was melted down for scrap metal at the start of the Second World War, along with field guns that stood outside the Drill Hall in the park.

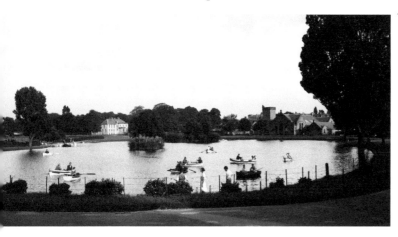

Left: Cooper Park showing Grant Lodge and Drill Hall.

Below: Cooper Park pond today.

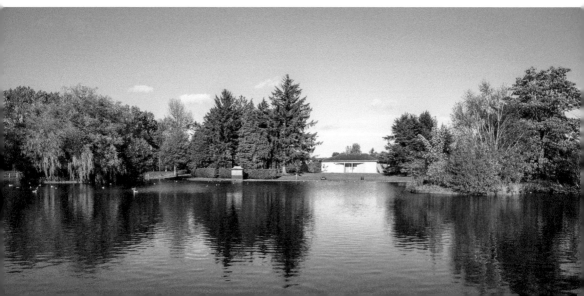

The County Buildings.

County Buildings

The Old County Buildings stood on the site of the town house of the Andersons of Linkwood and the centre of the council table was made from one of the old Tolbooth doors. Work started on a new block of buildings in 1937 but the Second World War caused a halt to construction. The New County Buildings opened in 1952, completed at a cost of £60,000, and contained meeting rooms for the Joint County Council and Elgin Town Council, along with offices for seventy staff.

Expansion and changes of administration meant more office space was required and a supermarket next to the County Buildings was redesigned and converted in 2012 into modern Moray District Headquarters at a cost of three million pounds.

Cutties Hillock

The name is thought to derive from the Gaelic 'hill-brow of the hunting'. Many fossils, including footprints of ancient reptiles predating the dinosaurs, were discovered in the now defunct quarries here and are now in Elgin Museum.

Nearer the present day, Cutties hillock was a scene of a close escape when a young naval Sub-Lieutenant of the Australian navy crashed his Sea Venom aircraft, striking three poles, narrowly avoiding some high-tension wires and passing within feet of forestry workers before crashing onto Cutties hillock. The pilot was flung clear as the plane ploughed downhill before bursting into flames a few feet away. Helped to safety by forestry workers, he escaped with a fractured collarbone and two bad leg fractures. Small remnants of the aircraft still remain amongst the undergrowth.

Moray District Headquarters.

Dandaleith Stone

Weighing nearly a ton, this stone was recently uncovered near Craigellachie by a farmer's plough. The incised carvings include an eagle, a crescent and V-rod, a mirror-case symbol and a rectangle and Z-rod, all of which are typical Class 1 Pictish symbols dating from the eighth or ninth century.

After conservation, much organisation and effort, this unique stone was installed on display in Elgin Museum in 2015.

Dandy Lion

This controversial and colourful statue was installed on the Plainstones in 2016. Part animal and part fish, it is designed to reflect local heritage. The fish tail is a

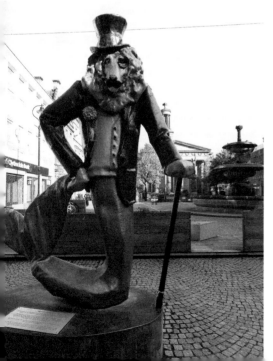

The controversial *Dandy Lion.*

reminder of the fishwives who came to sell their wares in the town. The clothing, as would have been worn by fashionable men of the past, reflects the weaving and mill tradition of the area. In his lapel is a flower – a dandelion, which would have been worn by those seeking work at the regular spring feeing markets held on the Plainstones.

While initial reaction to the statue was not all positive, the *Dandy Lion* has undoubtedly brightened up the town centre and attracted attention, reminding viewers of some of the complex town history, as well as raising many a smile.

Deanshaugh

Erected before 1224, an old bridge here was called 'Archibold of Inverlochty's bridge' and was near an old ford, enabling bishops and clerics to pass dry-shod between Spynie and the cathedral.

Towards the end of the eighteenth century, John Ritchie erected a mill here for the manufacture of tobacco, a waulk mill, a flax mill and bleaching machinery. By the late nineteenth century these were all replaced by a sawmill but this fell out of use in the early twentieth century.

Distilleries

Elgin lies in whisky country and there are two distilleries in the immediate area of the town.

Glen Moray distillery lies beside the River Lossie. It began as a brewery in 1830, and took power and water from the river, and was converted into a distillery in 1897. It closed in 1910 but reopened in 1923, the present owners being the Glen Turner Company.

The original buildings lay near the site of the ancient gallows, place of public executions until the seventeenth century. The main Elgin–Inverness road once ran through what is now the distillery site.

Nowadays housing developments lie close to the distillery and the main road runs a newer route nearby. Visitors can enjoy popular and informative tours of the distillery, which produces a fine single malt.

Linkwood distillery was founded by Peter Brown in 1821. Peter Brown was the younger brother of Sir George Brown, commander of the famous Light Brigade during the Crimean War.

Linkwood distillery, with distinctive 'pagoda' roof and two different still houses, draws its water from springs near the Millbuie lochs outside the town. It was extensively upgraded in 2012. Now owned by Diageo, Linkwood's single malts are used in blends such as Johnny Walker and White Horse.

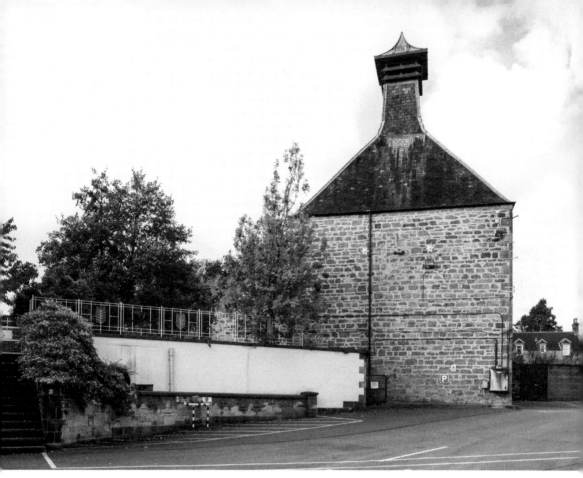

Linkwood distillery with distinctive 'pagoda' roof.

Doocot

At one time no estate was complete without its doocot (dovecote) which provided a source of fresh food, and the destruction of a doocot was once a felony. Doocots could cause disputes – if built too close to a neighbour's fields the birds would feed and fatten on their crops and consequently in 1617 an Act was passed preventing the building of doocots close to a neighbour's land.

The park at New Elgin is named after the stone beehive-shaped doocot there which dates to the sixteenth or seventeenth century. This structure contains space for 480 nests, the bird entrance being a circular hole in the top, and wide strong courses to prevent vermin climbing up to the nests on the ledges. There would have been a specialist ladder, or potence, to enable the collection of eggs or birds.

A listed building, the New Elgin Doocot was originally the property of Thunderton House, but is now in the care of the Moray Council.

The doocot of Lesmurdie Estate is now surrounded by the housing development of Chandler's Rise.

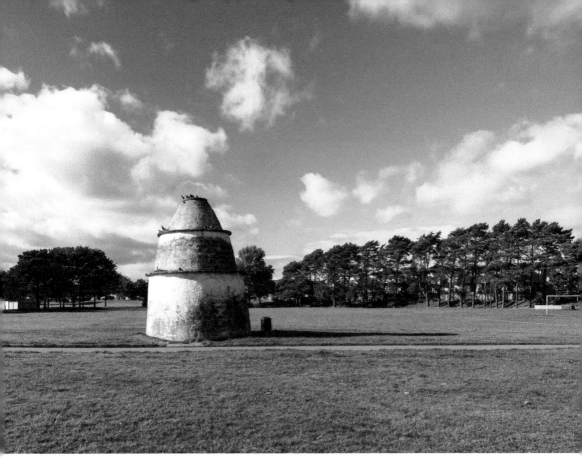

The Doocot, New Elgin.

Dunkinty

During the fifteenth century there was constant rivalry between the great houses of Gordon and Douglas. A battle took place south of the city; half of the town was burnt and in a subsequent battle hundreds of fighting men were slain. This gave rise to the jeering rhyme 'Where are your men, thou Gordon so gay? In the Bog o' Dunkinty, mowing the hay!'

In the early seventeenth century, the lands of Dunkinty were granted to Alexander Gordon who was involved in a commission of 1624 for suppressing reivers, or poachers. In retaliation, when he was out hunting with his son and servants in 1633, his party was attacked and killed by a band of reivers. Gordon was buried in an aisle of the cathedral while the head of one of the reivers was set on an iron stob on the Elgin Tolbooth.

Dunkinty House had an entrance at the foot of Lossie Wynd, near the Bishop's Palace, and was much admired as a luxurious building, decorated with coats of arms and hangings of Spanish leather. It fell into ruin and was eventually pulled down. The old Dunkinty Road led from the Bishop's Palace to the Lossie River.

Earl of Elgin and the Marbles

This peerage began in 1633, the most famous of the Earls of Elgin being Thomas Bruce (1766–1841), the 7th Earl of Elgin and 11th Earl of Kincardine. A British diplomat and ambassador, he became fascinated with the sculptures on the Parthenon at Athens and, realising they were in danger of being destroyed, he transported them to England. He was criticised for his actions but later vindicated by a government committee. The sculptures, now known as the Elgin Marbles, were purchased for the nation in 1816 and eventually placed in the British Museum, London.

Elgin

The exact origin and meaning of the name is uncertain, not helped by the erratic spelling of ancient times, but there are several theories – some more unlikely than others.

Remains of an ancient iron seal inscribed 'Helgun' could indicate a derivation from the 'Helgy' to hunt and 'fin', meaning fair, so meaning a pleasant hunting place. Saxon language has 'hely', meaning 'holy', and 'dun', meaning hill or fortress, which could suggest 'helygun', a holy hill. Others think it means 'little Ireland'.

Another theory is the name originates from the Celtic word 'aille', meaning beautiful spot or valley, and ending in the diminutive 'gin', which combines to mean a beautiful little valley. There are several other theories, so take your pick!

Episcopal Church

Part of the worldwide Anglican communion, the Episcopal Church has been an independent Scottish Church since 1690. Before the religious revolution of 1688, the majority of Scots had accepted the rule of bishops (Episcopy) but, following violent upheavals, the Presbyterian Church of Scotland was formed – a Church without bishops. Many members of the landed gentry in this area remained Episcopalians and occasionally were able to use Greyfriars Church for worship.

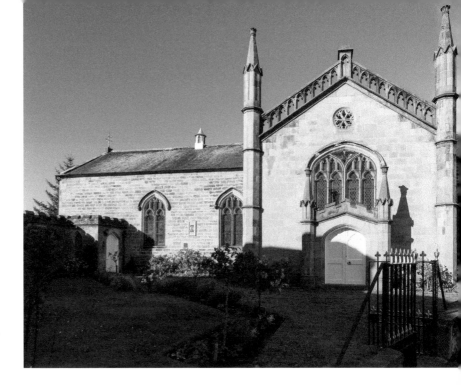

Holy Trinity
Episcopal
Church.

Having supported the House of Stewart during the rebellion of 1745, Scottish Episcopalians were accused of being Jacobites, were persecuted and scattered by the Duke of Cumberland after the Battle of Culloden. Some were murdered, others jailed or transported and their meeting houses burnt down or demolished. Conflict and repression continued until, after the death of Prince Charles Edward Stewart, penal laws were repealed in 1792.

Gradually new churches were built and although the Episcopal Church is in communion with the Church of England, it remains an independent body.

Holy Trinity, with its distinctive Gothic entrance, is the Episcopal Church of Elgin and was built in 1826, following the opening of North Street four years earlier.

Execution

Gallow Hill, near Brucelands, was once the place of public execution until the 1600s.

Until 1713 the sheriff of the county decided on capital offences and the last criminal to be treated in this manner 'according to the tenor of the sentence and form and custom of the nation' was an army deserter, Andrew Macpherson. He was sentenced to be hanged on the gibbet of Elgin, on Gallow Green, near Maryhill, and was executed there on 24 May 1713 and dismembered. His head was then placed on a spike on top of the jail stair, his right quarter hung by the West Port and his left quarter by the East Port of the town.

The last public execution in Moray was that of William Noble, also an army deserter. Near Barmuckity, on 28 December 1883, he robbed and murdered William Ritchie, a labourer from Lhanbryde. The execution took place in 1834 in front of one of the upper windows of the old Tolbooth.

Ex-servicemen's Club

Known as St Giles, the building was erected on the site of the Old Lodge and the site of the town house of Cummings of Lochtervandich. A stone plaque, high on the wall, with the initials 'IC IC 1576', is from the original Cummings' house. An ornamental stone arch surmounted by a carved lion is all that remains of the Old Lodge gardens.

The present building was designed in 1893 in Scots Baronial style. It was badly damaged by fire in 1973 but was successfully restored and reopened in 1976.

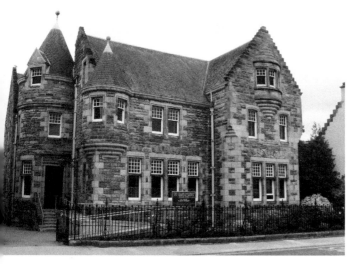

Left: Ex-servicemen's club restored.

Below: Ex-servicemen's club after the 1973 fire.

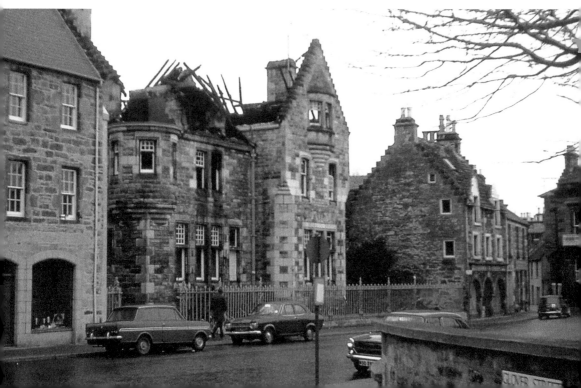

F

Famine

In the eighteenth century people relied on cereals for their staple food, wheaten bread was only available in towns and the country folk subsisted on oat, rye, barley and pease bread.

Following a failure of the harvest in 1742, thousands of destitute people roamed the towns and countryside and many perished. Lady Dunbar of Burgie, who was residing at North College Elgin, daily provided a large pot of brochan (porridge) for the starving people. Despite her efforts many starved to death, their bodies lying in the lanes throughout the town.

Farming

Elgin is surrounded by fertile farmland with a wide range of agricultural crops and livestock. Just outside today's town, where Neolithic man once farmed, hundreds of happy free-range hens providing delicious eggs are now guarded against marauding foxes by a group of alpacas.

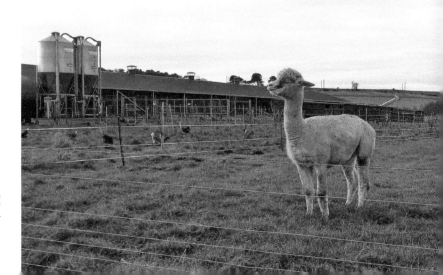

Alpaca guarding
free-range hens.

Ferrier

Alexander Michael Ferrier ('Sandy') was living in Fife Park Cottage, South Street, when he joined the navy in 1936. At the outbreak of the Second World War he was assigned the post of signaller in the Polish navy. He quickly learnt to speak Polish and in 1940, while he was recovering from injuries, he was awarded the Polish Cross of Valour for his bravery during the second Battle of Narvik.

Following his recovery, he began training for a secret mission with the Royal Navy at Chatham. In 1943 he went on a mission to fix limpet mines to an enemy cruiser in Palermo harbour. This was done by use of a manned torpedo called a *Chariot*.

The mission was successful and the cruiser was sunk, but due to a compass failure, Ferrier was unable to return to his rendezvous with the submarine *Thunderbolt*, and was taken prisoner by the Italians and later the Germans. He may have had a lucky escape as *Thunderbolt* was later sunk with the loss of all hands.

Sandy survived interment and returned home to be awarded the Conspicuous Bravery Medal by King George IV in 1945. Ferrier Terrace, Bishopmill, was named in his honour.

Fire Station

For over a hundred years Elgin Fire Service has had links with one particular Elgin family. George Bain moved from Glasgow to start a slating business but in 1898, knowing he had served in the Glasgow Fire Service, the Provost of Elgin asked him to establish a town fire brigade. George recruited his brother Hugh and in 1922 George's son, also George, joined the service. While continuing with their slater's business, several members of the Bain family gave sterling service to the Elgin Fire Brigade.

In 1976, William Bain, great-grandson of the original George Bain, was awarded the British Empire Medal for his distinguished service to the community, having been in the fire service for forty years. Both his sons joined the full-time ranks of the Grampian Fire Service. David Bain, assistant divisional officer who retired in 2001, was the last Bain family member to be in charge at Elgin.

Elgin Fire Station – main entrance.

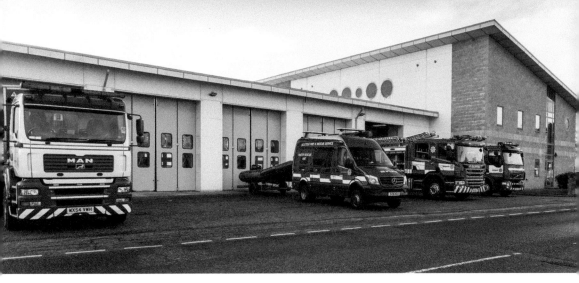

Fire engines at the ready.

In 2001 the fire station was moved from Haugh Road to a new £2.5 million premises in Wards Road and the old station was demolished to make way for a supermarket.

No longer merely Elgin or Grampian, the new Scottish Fire Station, with its specialist equipment, covers the whole of Scotland, including the Highlands. It has extensive training facilities and deals with around 500 call-outs a year.

Floods

Elgin and the surrounding lands have been subjected to flooding for centuries, with over twenty flood events recorded since 1750. Records state that the whole of the low county of Moray was deluged by waters of the Firth in 1010. The River Lossie that runs through Elgin has changed course several times over the centuries, often flooding the town.

The Muckle Spate of 1829 was recorded in detail, and published in 1873 by Sir Thomas Dick Lauder:

> The mills and farm-offices of Oldmills were filled with water, to within a foot of the door lintels in most of them and up to the roofs in some of the houses. The old Bow Brig stands on this farm. Its single arch, of great antiquity, withstood the force of the flood, but was partly relieved by water breaking out over the low land. All the flat land lying to the north of Elgin with its gardens and nurseries presented one unbroken expanse of water ... The bridge of Bishopmill, of two arches, was swept away by the accumulated pressure on it. All the houses ... in the suburb of Bishopmill running eastward by the base of the hill on the left bank were filled 6 to 8 feet deep with water. Those who had houses of one storey were obliged to flee for their lives One immense stream ran up the road from the Pans Port, past the large beech tree to the turnpike road and along its line for a mile, as far as the Stonecross hill. Part of it broke over the road and flooded the lands of Maison Dieu as far as Ashgrove.

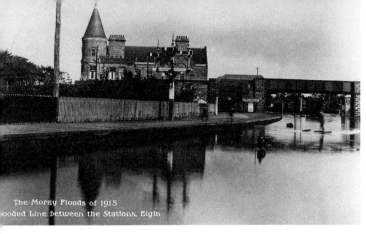

The Moray Floods of 1915
ooded Line between the Stations, Elgin

Floods at the GNSR station, 1915.

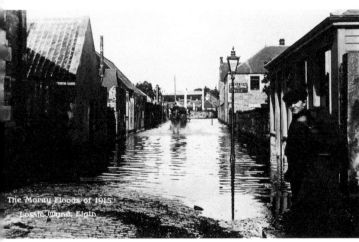

The Moray Floods of 1915
Lossie Wynd, Elgin

Floods in Lossie Wynd, 1915.

There have been several floods since the Muckle Spate but none quite so severe.

After serious flooding in 2002 when over 200 households were evacuated and transport links severed, work was instigated on a major flood alleviation scheme for Elgin. The £86 million scheme was completed in 2016 but even before completion it had protected properties during a flood event in 2014, preventing estimated damages of £29 million. The scheme now provides protection from flooding from the River Lossie for 860 residential and 270 commercial properties in Elgin.

Football

In 1890 an Elgin 'loon', British vice-consul Edward Johnston of Newmill, Elgin, formed the Sevilla Football Club along with other British residents and was elected president. A few weeks later the first ever match on Spanish soil took place, Sevilla beating a recreation club, Huelva.

In the late 1800s there were several football clubs in Elgin but in 1893 Elgin City Football Club and the Highland League were founded. Colonel Culbard generously gifted Milnefield Park, New Elgin, as the ground for Elgin City Football Club from 1885 and a grandstand was erected there in 1899.

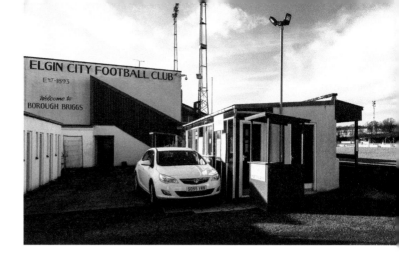

Elgin City Football Club entrance.

In 1909 Elgin City Football Club moved to new grounds, enclosed by a 6-foot-high fence, sited south of the Highland Railway Station and known as Station Park. After officially being declared open by Provost Wilson, a Highland League match was played between Elgin City and Inverurie Thistle. On New Year's Day 1910 a grandstand was opened in Station Park.

During the First World War the football ground was given over to food production and the pitch was moved to the Cooper Park between 1919 and 1921.

The club moved to the Borough Briggs site in 1921 and Elgin City joined the Scottish Football League in 2001, becoming the most northerly league club in Britain.

Fountains

A fountain was erected in 1846 on the Plainstones on the site of the old Tolbooth and Burgh Council House. It was once surrounded by iron railings and was dry for most of the twentieth century, but water was restored in 2002.

A drinking fountain was installed outside the Church of St Giles in 1860, funded by local tradesmen, but was removed in the nineteenth century.

Fountain on the Plainstones.

At the west end of the town the Elgin Amenities Association built another fountain in 1892 but this was removed in 1949 to make way for a roundabout. It was abandoned in the Cooper Park pond for years until being reinstalled in 1997 outside the original entrance to the hospital.

Fossils

Elgin Museum is home to a world-famous collection of over 900 fossils, which is certified as an 'Officially Recognised Collection of National Significance to Scotland'. Many of the specimens were discovered in several local quarries. Footprints and fossils, predating dinosaurs, from millions of years ago were preserved when the sandstone was formed in arid conditions near the equator, before movement of plate tectonics shifted Scotland to its present position.

These historically and scientifically important fossils, also known as the 'Elgin Reptiles' and including the famous so-called 'dinosaur footprints', can be seen in the world-famous Elgin Museum collection. A model of a pareiasaur, *Elginia mirabilis*, which predates the dinosaurs and which was named after the town, is also on display.

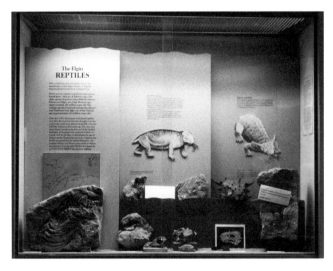

Some of the Elgin Reptiles in Elgin Museum.

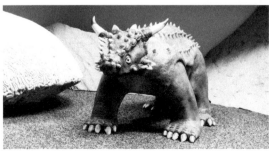

Model of the famous *Elginia mirabilis*.

G

Golf

The earliest reference to golf in the north of Scotland is in the 1596 Records of the Kirk Session of Elgin, in which Walter Hay, goldsmith, was accused of playing golf on a Sunday during the time of the sermon, much to the disapproval of the kirk, which constantly named and shamed such miscreants. The links that had been used for years became the farmland of Linksfield around 1760.

Elgin Golf Club opened in 1906, with just six holes and a clubhouse which was more of a shed. A larger clubhouse was opened in 1909 and it was 1920 before the club acquired eighteen holes. The clubhouse was replaced in the 1950s and further extended and modernised in 1971 to include new locker rooms, a new veranda and sun porch.

Gordon & Macphail

Established in 1895, this family-owned business originally sold groceries, wines and spirits. The firm soon developed a successful whisky broking business and continues

Offices and warehouses of Gordon & Macphail.

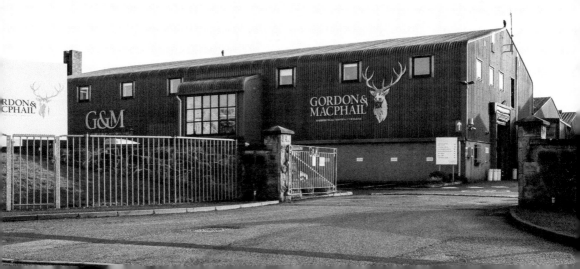

to deal with mature whiskies. It also blends and bottles whiskies under its own labels, buying new whisky from Scotland's leading distilleries to mature in selected casks to be bottled when at its best.

The shop on South Street sells high-quality delicatessen items and hampers as well as stocking some very rare whiskies and the firm continues to collect and export possibly the largest range of whiskies in the world.

Gordon Monument

The prominent family of Gordon owned large swathes of territory in Moray, including Gordon Castle and estate on the banks of the River Spey, a few miles east of Elgin. The family moved in high circles and over generations of battles, feuds and land reform, wielded great influence.

The monument on the top of Ladyhill overlooking the town is that of George Gordon, the 5th and last Duke of Gordon, born in 1770. He was an agricultural reformer and the founder of the Gordon Highlanders, was appointed Lord Lieutenant of Aberdeenshire, Keeper of the Great Seal of Scotland, Chancellor of Marishall College and was Lord High Constable at the coronation of George IV in 1820.

The duke died in 1836; the 80-foot-high Tuscan column was built by public subscription in 1839 and the 12-foot-high statue of the duke was positioned there in 1855.

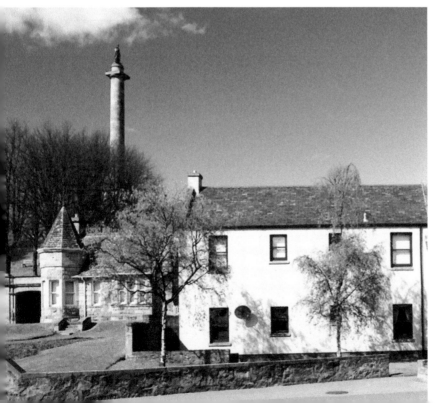

Duke of Gordon monument on top of Ladyhill.

Grant Lodge

Built in 1765 on the site of the previous town residence of the Marquis of Huntly, Grant Lodge was a residence for the Seafield family and the renowned architect Robert Adam was commissioned to design the building.

Grant Lodge was the scene of a serious political riot and the last clan uprising during a parliamentary election in 1820. Feelings had been running high between supporters of two rival parties and several dubious tactics had been employed, including bribery and the kidnapping of prominent supporters by both sides. Men roamed around the town armed with bludgeons and old swords.

Lord Seafield and his three sisters were then living in Grant Lodge and, subjected to harassment, the ladies in the Lodge began to fear for their own safety. A messenger was sent in haste to Strathspey clansmen asking for help. The fiery cross was sent around the district and over 600 Grant clansmen gathered and marched to Grant Lodge. They were armed with muskets and swords but were aiming to quell, not start, trouble and were accompanied by skirling pipes.

Elgin Burghers were terrified and the Provost of Elgin, backed by a deputation including the sheriff and all the parochial clergy, is reported to have slipped through the back door into the Lodge to plead on his knees that the town be spared and the Highlanders be sent back to Strathspey. Once assured that they would no longer be subjected to harassment, the ladies agreed to send their bodyguards away.

The town remained in a state of alert until after the election when the kidnapped victims, which included town councillors, were returned unharmed.

The lodge, situated in 40 acres of ground, was surrounded by a high wall and was refashioned over the years. A new entrance to the park was made in 1851.

Grant Lodge unused.

In 1899 the property was sold by the Countess Dowager Seafield to local lawyer Sir George Cooper, who then gifted the lodge and the park to the town in 1902.

There was a public holiday and a large crowd witnessed the formal ceremony of handing over the park to the town. Later that day, during a formal lunch in the Town Hall, Sir George Cooper was granted the Freedom of Elgin.

The wall was demolished, replaced by railings, and the public library was moved into Grant Lodge in 1903. In 2003 Grant Lodge was boarded up after being badly damaged by a fire and now awaits a decision on its fate.

Gray, Doctor Alexander

Alexander Gray was born in Elgin in the early 1750s. His father was a wheelwright, watchmaker and keeper of the town clock. After an apprenticeship with an Elgin doctor, Alexander studied medicine in Aberdeen, qualifying as a surgeon in Edinburgh. He worked as a ship's surgeon before joining the East India Company's medical service in 1782.

His marriage to Eleanor Robertson in Calcutta in 1799 was a dismal failure and they separated with great acrimony five years later. Alexander died in India in 1807.

In his will Alexander wrote scathingly bitter comments about his wife and his sister, settling sufficient money on them both but bequeathing the principal part of his fortune, amounting to £20,000, to his home town of Elgin for the establishment of a hospital 'for the benefit of the sick and poor of that town and the benefit of Moray'. His will was unsuccessfully contested by the family for years before the hospital was built.

Gray's Hospital

Named after its founder, the surgeon Alexander Gray, the foundation stone for Gray's Hospital was laid in 1815, the day the news of the victory of the Battle of Waterloo reached Elgin. The hospital, then known as the Institution, was opened in 1819. The original ornate building, with great Doric columns, had thirty beds. Physicians, matron and dispensary were on the ground floor. Separate well-lit wards with females to the south, the male ward to the north, were on the first floor and the ward for smallpox and fever patients on the second floor.

Perspicaciously, in his will Alexander Gray stipulated that 'In order to prevent abuses incident to such Institutions, I direct that no person who has any charge or control of the Institution be employed either directly or indirectly on supplies for the sick.'

The first patient was admitted in 1819 and in that first year 200 patients attended. In order to receive treatment, patients had to produce a note of recommendation from their local kirk minister. Some who needed urgent help were sent home if they lacked the necessary paperwork and initially Episcopalians and Catholics were turned away.

By the 1850s there was a separate access to the attic storey, which housed fever wards until a separate fever hospital was built in 1900 at Spynie. A major extension was built in 1909 and formal training for nurses began around that time. Many changes and expansions took place over the years, altering the original classic proportions. A new wing with a medical ward and X-ray department was opened in 1939.

During the First World War the hospital was used by the Admiralty and in the Second World War by the Royal Air Force and the military.

After a vigorous campaign the distinctive façade was saved from demolition and in 1970 a new operating theatre was built. During renovation work in the 1980s the impressive drum tower with cupola was discovered to be held up by little else than 'good fortune and spider's webs'!

Major redevelopments costing £22 million were undertaken between 1992 and 1997, constructing new operating theatres, lifts, obstetrics, gynaecology and paediatric facilities, outpatient clinics, an acute psychiatric ward and a new accident and emergency department.

A further £3 million development in 2012 resulted in further upgrading.

Nowadays Gray's Hospital has a new entrance and reception area and a large modern hospital development at the rear of the original building, retaining the 1819 frontage in all its splendour.

Frontage of Gray's hospital before modern expansion and developments.

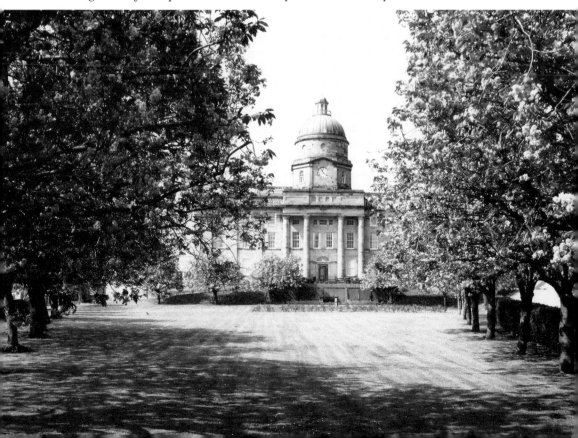

Greyfriars Convent

The Franciscan Order of Greyfriars had their first convent in Elgin near the cathedral but it was destroyed by the English army of Edward I. Around 1479 another convent was built on the present site but following the Reformation of 1560, the building gradually deteriorated. It was used for a time as a meeting place for the Incorporated Trades before falling into private hands.

The Emancipation Act of 1829 finally allowed Catholics to vote and take their place within society without persecution and in 1871 a small community of nuns came to live in Elgin. They began a small school close to St Sylvester's Church and took in girls from poor families as boarders, training them and enabling them to find work as teachers.

The Marquis of Bute purchased the ruinous property of Greyfriars for the Sisters of Mercy in 1891 and restoration work began. During restoration workers discovered a mummified cat, a rat and a starling within the walls, placed there when the convent had originally been built.

Mass was celebrated at Greyfriars Convent in 1898, for the first time in the 300 years since the Reformation.

A succession of Sisters of Mercy – up to seventeen at a time – were based in Greyfriars Convent, continuing their vocations of teaching and ministering to the poor and needy in Elgin. By 2010 the four remaining elderly sisters had to move to a smaller house and, although they continued to comfort and visit the sick, the future of the convent was uncertain. However, in 2013 four young Dominican sisters from America took up residence in Greyfriars, working with young people and families and the convent remains a centre for faith and good works within the diocese.

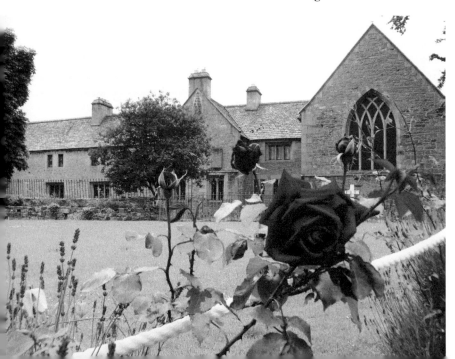

Greyfriars Convent.

Hangman's Ford

In 1811 shoemaker Alexander Gillan was executed for the murder of a young girl near Spey Bay. He was hanged near the site of the murder by the executioner from Inverness and, on the orders of the Sheriff, his body was 'hung in chains to be devoured by the birds of the air'.

The inefficient executioner, William Taylor, caused outrage by botching the job. A few months later he received a letter advising him of a vacancy for an executioner in Aberdeen, so he set off to apply for the post. When he reached Elgin, Taylor was set upon by a mob which included apprentice shoemakers. They chased him out of town, prodding him fiercely with their awls, forcing him to wade across the Lossie in the area near the Haugh, now Hangman's Ford.

Forced to run for his life, Taylor collapsed near Forres and was found dead in a ditch the next day and was buried without ceremony.

For their part in the assault on Taylor, two shoemakers' apprentices were sentenced to transportation for seven years.

Harrison

Edward S. Harrison OBE (1879–1979) joined the firm of Johnston and Co. in 1904 as a junior partner. In 1920 he became head of the company, establishing it as a world-famous textile firm. He joined Elgin Town Council in 1932 and held many posts, including that of Lord Provost for seven years, until his retirement in 1949. He was a founder president of Elgin Rotary Club, founder member of Moray Bowling Club and of Elgin Golf Club, had a wide range of interests in the arts and in old vernacular buildings and was a strong supporter of Elgin Museum.

The Freedom of Elgin was conferred on him in 1964 and a terrace of houses at Bishopmill, designed in 1949 and built in the Scottish Vernacular style, was named in his honour.

Another outstanding member of the family, John A. D. Harrison OBE (1932–2001), joined the family company Johnstons in 1955, succeeding his cousin 'Ned', and became

managing director in 1972, and chairman in 1979. He became chairman of several textile councils and was awarded the OBE in 1982 for his service to the industry. He also found time to devote his energies to public service and to the arts.

Highfield House

Built in 1820 and originally called Northfield, this was the aristocratic, fashionable town house of the Dunbars of Northfield who resided at Duffus. The Dunbars were the Constables of the castle of Elgin in the fifteenth century and the King's Regent in Moray. The house was renamed in the mid-nineteenth century when it changed hands. It is now divided into offices with a doctor's surgery at the rear of the property.

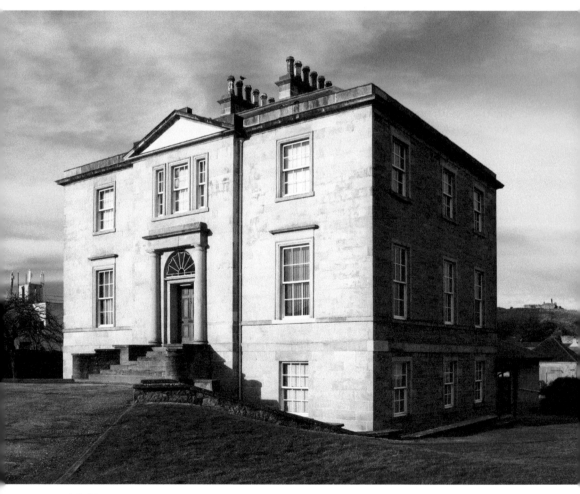

Highfield House.

High School

Elgin High School lies south of the railway line and takes pupils from the southern districts of the town. It opened in 1978 and a new building, designed for 800 pupils and costing over £28 million, was constructed in 2018. The old building was demolished.

The school has received awards for its global links and fundraising efforts and has a partnership with a school in Zambia with exchange visits being organised between the two schools.

High Street

In the fifteenth century 'the heget' extended only from West Port south of Ladyhill down to the East Port, widening around the then tolbooth and St Giles Church and kirkyard. Many narrow lanes – closes – branched off the High Street, each with eight or ten dwellings and terminating in gardens that led directly to the countryside.

Most of the old houses along the High Street had high-pitched roofs overlaid with thatch or heavy grey slabs and many had piazzas, some of which can still be seen at the east end of the street.

The road, with no pavements, was an ancient causeway that rose high in the middle with a ridge of stones providing the only dry walkway from West Port to Little Cross. Open drains ran along the street and were crossed by common gutters carrying all sewage to open ditches.

In the early nineteenth century, when the hospital and Anderson's Institute were being constructed, the north side of the street had fifty-four dung heaps and twelve pigsties. A large open ditch ran from the top end of town, now South Street, across the High Street and flowed as an open ditch across Borough Briggs into the River Lossie.

In 1820 the town council, aided by the Earl of Fife, began levelling and upgrading the road and converting the open ditch into a covered drain. Many residents of older properties were rehoused in Bishopmill in order to carry out this work. The gutters from the closes were only covered over after an outbreak of cholera in the 1850s.

Families continued to live in the old, dark, and cramped closes that ran off the High Street until after the Second World War when many were rehoused. Some of the old houses were demolished and, during the construction of the Relief Road in the 1970s, many of the closes were shortened and more than fifty medieval buildings – some listed – were demolished.

On the south side of the street were once eight inns and hotels – the Plough Hotel, the Star Inn, the Fife Arms Hotel, Harrow Inn, Gordon Arms Hotel, Newmarket Hotel and the Commercial Hotel – all now gone.

The building boom which began in 1820 steadily transformed the face of the High Street; new elegant Georgian buildings appeared, followed by a spate of Victorian buildings. Some were demolished in the flurry of 1960s modern developments.

Thankfully when a new £7 million shopping mall was planned in 1985, a large part of the High Street façade was preserved, remaining virtually unchanged with all the development being at the rear of the properties. Originally built in 1904 for A. L. Ramsey, draper, the St Giles building façade was retained when a new large shopping centre was built in 1991.

Left: One of the old hotels.

Below left: Ramsey's, Nos 123–127 High Street.

Below right: St Giles shopping centre entrance.

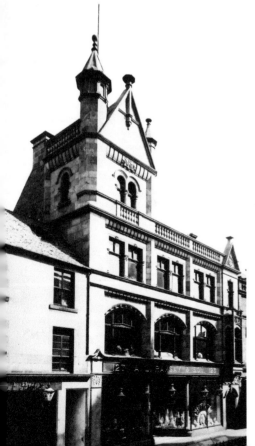

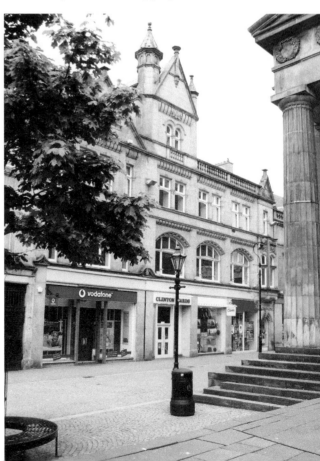

I

Incorporated Trades

Under a charter granted by Alexander II in 1234 the assorted trades of Elgin were permitted the rights of a merchant guild and formed themselves into corporations. Each craft had a place in St Giles Church with its own patron saint and priest. The six Incorporated Trades of Elgin played a vital role in the development of the town.

During the upheavals of the Reformation of 1560, six of the craft guilds – Hammermen, Glovers, Shoemakers, Tailors, Weavers and Squarewrights – formed themselves into a Convenery to protect their privileges.

In 1675 the Deacon Convenor became a member of the town council and eventually the Incorporated Trades acquired considerable political influence, crafts jealously guarding their monopoly.

In the eighteenth century the election of the Member of Parliament rested with the town councils – a system open to attempts of bribery and corruption. At one point the Deacon of the Wrights received a book of psalms from a hopeful candidate, the Earl of Fife, but every one of its psalms was a pound note!

The Reform Act of 1832 put an end to these practices and some of the land owned by the trade Corporations was sold. This revenue was divided between the six craft incorporations and distributed to widows and the needy.

The Riding of the Marches by the Incorporated Trades began in Elgin in 1657, latterly taking place every two years. The trade guilds were closed in 2014 and archives and objects, some dating back to the thirteenth century, were donated to Elgin Museum.

Jacobites

In the Jacobite rising of 1715 Elgin was suspected of housing Jacobite rebels and, on orders from the Commander of the King George's forces, searches were made. The townsfolk were relieved of '63 guns, 45 muskets, 32 small swords, 21 broad swords, four Danes' axes, three carbines, two halberds and a great number of pistols'.

The next rising of 1745 caused much more disturbance in the town and surrounding areas with many supporting the cause of Prince Charles Edward Stuart. The king's forces, commanded by Sir John Cope, encamped at Elgin. Compulsory purchases of food and livestock, including horses, were not always paid for and, as usual with occupying forces, they left complaints of damage to corn fields and of food shortages in their wake.

In the spring of 1745 'Bonnie Prince Charlie' spent several days in Elgin, on his way to Culloden, apparently recovering from a bad cold. He stayed as a guest of Lady Arradoul in Thunderton House.

A short time later the Duke of Cumberland passed through Elgin on his way to the decisive Battle at Culloden. Afterwards, many local Jacobites were punished, losing property and being imprisoned or transported.

Johnstons of Elgin

A mill was established in 1797 at Newmill on the banks of the River Lossie. Originally a meal, flax, tobacco and carding mill belonging to Joseph King, it eventually became a linen mill.

Twenty-three-year-old entrepreneur Alexander Johnston opened his firm here in 1800 and soon changed to manufacturing woollen cloth, especially estate tweeds. His son James joined the business, pioneered the weaving of vicuna and cashmere in 1851, exhibited successfully in London in the Great Exhibition of 1851 and at the Paris exhibition of 1855. James added an iron foundry to the business and the firm of Johnstons became the largest employer in the area, with twenty-two weavers' cottages nearby.

Machinery was originally driven by water power from the River Lossie, but as production increased, a steam engine was employed and in 1908 four separate gas-driven engines were installed.

Like his father, James Johnston took an active interest in community affairs. He was a successful farmer, director of Elgin Museum, honorary sheriff substitute and was involved in the building of the Victoria School of Science and Art.

By 1867 James was joined by his son Charles and eventually the company began trading with the USA. James died in 1897 and Charles continued with the business. In 1904 Edward S. Harrison joined the firm as a junior partner.

Charles Johnston lost all enthusiasm for the business when his son was killed in the First World War and he sold his interest in the firm to employee Ed Harrison.

In 1920 Ed Harrison became head of the company, establishing it as a world-famous textile firm. On a visit to America he recognised the demand for a lighter cloth than heavy tweed and began the lucrative scarf trade which kept the firm going through the years of the Great Depression.

During the Second World War all woollen manufactures had to make khaki cloth for the army. Wool supplies were rationed and there was a shortage of workers but Johnstons continued to function.

By 1970 the firm had expanded and in 1978 was awarded the Queen's Award for Export. In 1981 Johnstons opened its first retail shop and new production facilities in Elgin. Another Queen's Award for Export was achieved in 1994.

Johnstons of Elgin visitor centre.

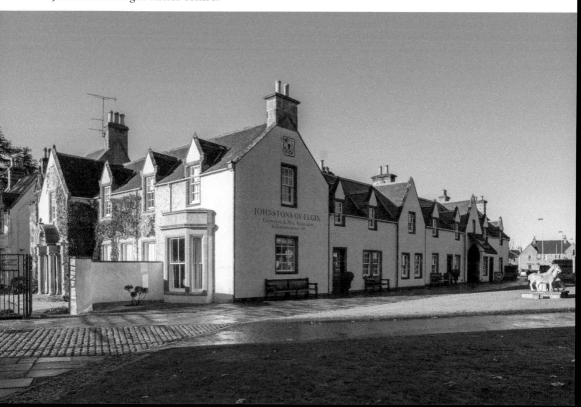

A flood in 1997 resulted in 4 feet of water sweeping through the mill, causing more than £20 million of damage. The firm made a good recovery, taking 'Scottish Textile Brand of the Year' at the Scottish Fashion Awards and developed a significant growth of customers in the couture sector.

Johnstons is now the only British mill to transform the raw cashmere fibre from China and Mongolia into a garment. A new visitor and heritage centre opened in Elgin and Johnstons of Elgin, with showrooms in London, New York, Paris, Dusseldorf and Tokyo, is now one of the most sophisticated weaving and knitting plants in the world, exporting over 1.5 million luxury garments annually worldwide.

Jougs

The jougs were a form of public punishment consisting of a hinged iron collar attached by a chain to a wall or a post and fastened around the offender's neck. Often the offender was conveyed the whole length of the town accompanied by a beating drum before being chained for all to see. There were several joug sites in Elgin, including outside St Giles Church and on the Little Cross.

K

Kesson, Jessie

Author Jessie was born illegitimate in the Inverness workhouse in 1916, her father later being registered as a cattleman from Lhanbryde. She spent her early years in poverty in an area of the High Street near Lady Lane – one of the notorious closes – and recorded childhood days playing on Ladyhill. She was sent to an Aberdeenshire orphanage and despite being denied a good education and suffering many tribulations, she later used her early experiences to write lyrical, moving fiction. She became a well-respected and prolific author, playwright and broadcaster.

One of her memorable books, *The White Bird Passes* (1958), was made into a film in 1980. A heavy smoker, she died of lung cancer in 1994.

Knock of Alves

Just outside the town on the road to Forres lies a small hill, the Knock of Alves, with an octagonal tower on the summit of what is reputed to be a fairy-haunted hill. The tower was constructed in 1827, within the outline of an ancient fort and next to the Forteath family mausoleum. It was named York Tower in honour of the second son of George III.

On the lower slopes of the hill there are remains of an ancient small stone circle. The old post road ran to the south of the Knock but was rerouted in 1819 and a toll house built in 1821.

Ladyhill

This hill was occupied during ancient times and there is evidence for an early seventh-century Christian community here. Once the site of Elgin Castle where Edward I stayed in 1296, by 1455 the castle had been totally abandoned with only faint ruins now remaining.

Balloons were all the rage in the eighteenth century and a report in the *Aberdeen Journal* in 1784 describes how a young man 'of uncommon talent' launched a balloon from Ladyhill. It vanished westwards and was later discovered to have fallen down a chimney where the astonished householder was manufacturing illicit whisky. The bursting balloon spoilt the whisky and scorched the legs of a girl who was warming herself by the fire.

The monument to the last Duke of Gordon surmounts the hill. In 1857 a Russian gun – the trophy from the Siege of Sebastopol during the Crimean War, was transported to Elgin station then taken to the foot of Ladyhill by wagon. Ropes were attached and it was rolled to the top of the hill. This cannon was melted down for scrap metal in the Second World War.

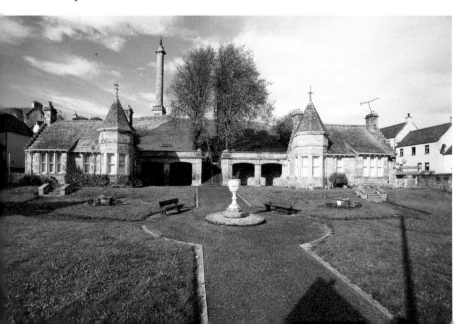

Memorial cottages at the foot of Ladyhill.

Rough excavations in 1858 on the hilltop revealed three skeletons, a flint arrowhead, pottery, a Charles II copper coin and an old quern.

The two cottages at the foot of the hill were donated in 1918 by Sir Archibald Williamson, MP for Moray and Nairn. The memorial gardens and the cottages, built in 1919, were in commemoration of the termination of the First World War. The cottages, named Sulva and Messines, each have a sheltered arcade incorporating old carved stones.

Laichmoray Hotel

Originally this was built in 1853 by the Railway Company as the Railway Hotel to serve the terminus of the Lossie-Elgin line.

From 1874, following the closure of Weston House (where Alexander Graham Bell once taught), it became the Elgin Educational Institute, a high-class school for the sons of gentlemen on their way to university. A series of large schoolrooms were added, but by 1879 the school went into liquidation and was sold.

In the 1890s it became the Station Hotel until being renamed as the Laichmoray in the 1950s.

Laichmoray hotel.

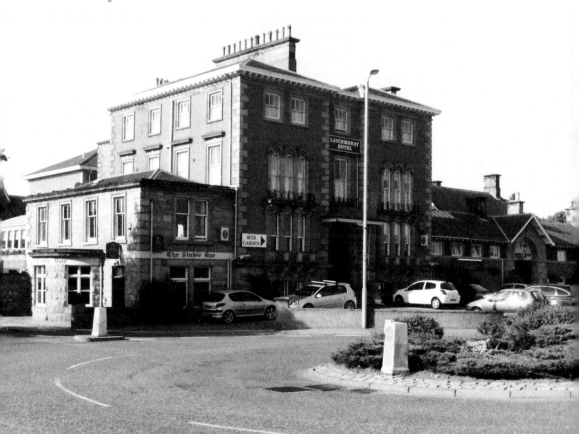

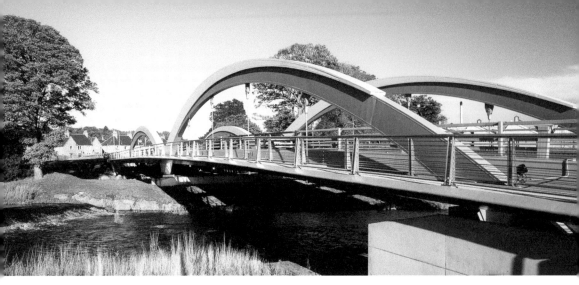

Landshut bridge.

Landshut Bridge

This new bridge, named in honour of Elgin's twin community in Bavaria, was opened in 2014. It replaced the old Pansport Bridge and, as part of the flood relief scheme, spans both the River Lossie and the new flood relief channel. It was erected by Cleveland Bridge UK, whose works include the Kessock Bridge, Inverness and the new Forth Crossing.

Leper Hospital

In past times, when the River Lossie ran in a hollow through the area of the Order Pot, the leper hospital was on the east side of the river, well apart from the town. No record exists of when it was built but leprosy is said to have arrived in the country along with returning Crusaders in the tenth and eleventh centuries. Between the twelfth and fifteenth century every town in Scotland had a leper house.

In 1850, when trenching part of Pinefield nurseries, extensive foundations of the leper house were discovered.

Lesmurdie House

This name of an estate on the Cabrach appears to derive from the Gaelic, meaning either 'the big fort' or 'garden enclosure'. Old legends mention the once vast forest of Lesmurdie where two sisters, both witches, once lived. The Elgin connection arose when William Stewart, a merchant in Gothenburg with Cabrach connections, returned to Scotland, married Barbara King of Newmill and gave the name to his Elgin home in 1773.

The Elgin property was once owned by General James Stewart King who opened up King Street and who owned Newmill.

Lesmurdie House, with its distinctive central tower, was enlarged in 1881 after being acquired by James Johnston of Newmill foundry and woollen mills. The property was owned by the Johnston family for over 100 years.

Between 2000 and 2007 the estate was broken up, part of the grounds developed into the housing estate of Chandler's Rise, and the house subdivided into flats.

The early nineteenth-century Lesmurdie estate doocot remains intact, surrounded by modern houses. It has a deep moulded rat course, a hexagonal roof and 174 nesting boxes in the first floor. It is thought that the first floor was intended as a hen house.

Library

The public library opened in 1892 with 3,366 volumes and was housed in a side room of the old Town Hall. Miss Isobel Mitchell was the first librarian and served for thirty-thrtee years. The library moved to Grant Lodge in 1903 and Miss Mitchell helped to organise a successful Art and Crafts exhibition to coincide with the grand opening of the Cooper Park and of Grant Lodge.

Despite repairs, over the years the condition of building deteriorated and a new library premises, which included a reconstructed Drill Hall, was opened in 1996, leaving the old building to contain local heritage records.

A fire in August 2003 caused some damage to Grant Lodge but thanks to efforts from volunteers, most of the local heritage records were salvaged and can now be accessed in a section of the main library.

Library incorporating the old Drill Hall.

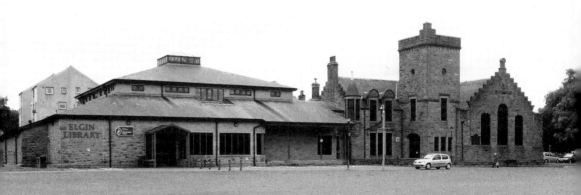

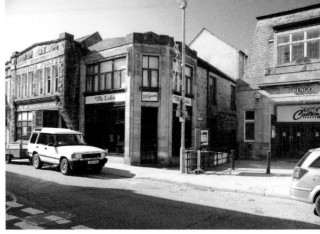

Above: The Lido building and the old Picture House.

Left: The old Palace Hotel building.

Lido

The Lido, an art deco building opened in 1927, is next to the picture house, beside the old newspaper offices and opposite the ornate old Palace Hotel buildings.

With café, shop, dance hall and billiard room, the Lido swiftly became a popular meeting place but times have changed; the Picture House is now a bingo hall and the once popular Lido is now partly occupied by small businesses.

Linksfield

This area was the golf links of olden times. Equidistant from the town and Spynie Palace, it consisted of sandy hillocks and gorse bushes throughout which the gentlemen and burgesses of the town enjoyed challenges with the clerics of the cathedral. During agricultural reform around 1760, the potential of the land was recognised and it became the farmlands of Linksfield.

Lime was discovered and quarried in the Linksfield area in the early nineteenth century. During this process several marine fossils of Lower Jurrasic Age were discovered, including some cervical vertebrae and a tooth similar to plesiosaurus remains from southern England. These are now held in the Geological Museum in Bath.

Linkwood

The extensive farmlands of Linkwood included flour, barley and meal mills in the eighteenth century. Records show an outbreak of foot-and-mouth disease in 1883 and of an experimental growing of turnips in 1888.

The distillery was founded in 1821 and over the years the old farmlands have given way to housing developments which cover the fields where once traction engine rallies were held.

Lion Arch

Overlooked by the flats at Northport, this ornamental 'folly' is all that remains of the Old Lodge and fine gardens at Nos 9–11 High Street, now the Ex-servicemen's club.

Little Cross and Well

At the west entrance to the cathedral precinct wall this very ancient stone cross is possibly the original stone cross on the site just outside the cathedral, as decreed by the then bishop. With the 'Jougs' attached, it was once the site of public punishment.

Nearby, the Little Cross well was said to supply the sweetest water in the town. Built in the 1640s, it was approximately 25 feet deep and was open with a surrounding wall. In 1811 it was covered over, a pump put into it and a man paid 7/- a year for opening

 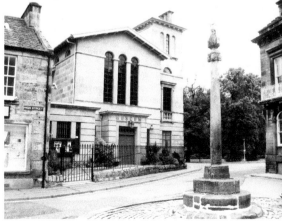

Above left: The Lion Arch.

Above right: The Little Cross.

and unlocking the pump. The introduction of water by gravitation put an end to the necessity for the well, but a hitch in supply in 1876 saw the well in use for a short time.

In the process of road resurfacing in 1956 the well was filled and covered over. A nearby wall plaque indicates the site of the old well.

Lossie River

The river that flows through the town begins its course at Cairn Kitty, where the last wolf lair in Moray was recorded in 1700. The river's name is thought by some to come from the old Latin for salmon. Others believe it to be from a more ancient language root, similar to Welsh and Norse, meaning 'light' or 'pure'.

Starting at 1,710 feet above sea level, the river runs for over 30 miles and old land records reveal that the Lossie has changed its course many times over the centuries and has subjected the town to some devastating floods.

The mouth of the river changed many years ago and in 1959 it was reported that spawning salmon were only able to get a little beyond Bishopmill bridge. New conservation regulations now make it a criminal offence to kill salmon within the Lossie district.

The oldest bridge in Elgin over the river, the stone Bow Brigg at Oldmills, was constructed in 1630–35. It was remodelled in 1789 and was the only Elgin bridge to survive the 'Muckle Spate' – the devastating Moray floods of 1829.

The river provided power for the many mills that lay beside it. The tan works had a flume for washing skins on the Elgin side of Bishopmill dam and, as water from the town wells was hard, women did their washing in the river beside this flume. With kilted-up skirts they would tramp washing in tubs on Lossie Green before hanging it up to dry on the public poles erected there for that purpose. Linen was laid out to bleach in the sun on riverbanks at Bleachfield, near Deanshaugh.

The Lossie has recently been subjected to a massive £86 million flood defence scheme, which will hopefully keep Elgin safe from future flooding.

River Lossie in Elgin.

M

Macbeth

Macbeth was a successful Mormaer, or ruler, of a large tract of northern Scotland including Moray. He was the last of the Pictish kings and, along with his wife Gruoch during his reign between 1039 and 1057, he managed to keep peace in a land plagued by strife and threatened by the Norse. He went on pilgrimage to Rome in 1050, leaving Gruoch in charge of his lands.

Macbeth and Gruoch were much maligned by Shakespeare who was trying to impress his patron, King James, a descendant of the man who killed Macbeth.

Maison Dieu

In the early thirteenth century Bishop Andrew of Moray founded this hospital near the Tyock Burn. It was said the splendid building equalled the cathedral in architecture but it was destroyed by the Wolf of Badenoch during his rampage of 1390. It was rebuilt, but fell into decay after the Reformation and the remains were carted away for reuse.

In 1594 James IV granted the lands of Maison Dieu to the town for support of the poor, resulting in the Bede Houses and the Sang School.

In 1773 the Scots magazine reported that a chapel used for worship in the centre of Maison Dieu park was blown down by a hurricane. No trace now exists.

Mansion House

A house was built in 1851 on the west side of Blackfriars Haugh, site of previous nursery gardens but once former monastery land. Originally known as the Haugh, the house was extravagantly remodelled in 1883 and was used in both world wars to accommodate service personnel.

The Haugh was gifted to the town in 1946 and was used as a pre-nursing training centre. It was sold to the council in 1969 used as a refuge for women affected by

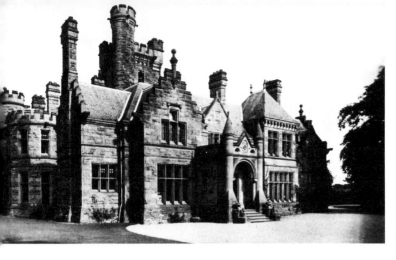

The Haugh.

domestic violence and later as a music department for Elgin Academy, but as its condition deteriorated, demolition was proposed.

After some lively debate the Haugh was declared a listed building and in 1982 was sold and transformed into a luxury twenty-three-bed hotel with a leisure complex and swimming pool. From 1983 it was known as the Mansion House Hotel, although many locals still refer to the building by its original name.

Mansefield Hotel

Originally the Church of Scotland manse dating from 1839, this property underwent many changes. Part of the grounds were occupied by a nursery garden and florist, and an electrical repair business. The building was extended and opened as the West End hotel in 1977 and featured the well, 'the wishing well', in the foyer. Extensive rebuilding created a luxury hotel in 1999 renamed the Mansefield.

The Mansefield.

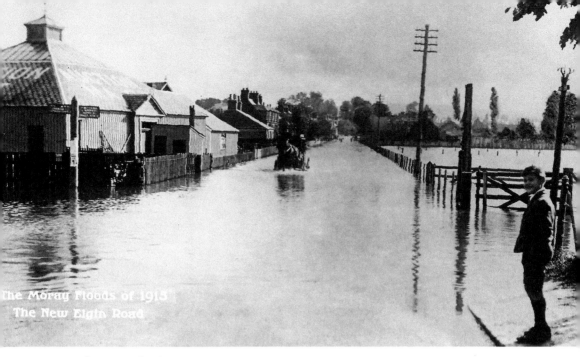

The Moray Floods of 1915
The New Elgin Road

New Elgin Mart floods, 1915.

Markets and Market Buildings

The eastern part of Maryhill garden was a market green for cattle markets long ago and a market cross was recorded in 1365 as being in the area around St Giles Church. A corn market merged into a general market every Friday night on the High Street and farmers would congregate after the auction sale.

A covered market building, Newmarket, was built in 1851, running through to South Street from the High Street.

By the late nineteenth century there were two auction marts in Elgin – the green mart near the present fire station and the red mart, the Northern Auction Mart in New Elgin. Only the New Elgin Mart remains, with its distinctive pagoda rooftop, but it no longer has livestock sales and some of its fields were developed in the 1970s into a housing estate.

Maryhill

On a map of 1822, Gallow Green is marked as being between Ladyhill and Maryhill; in January 1685 the justiciary court had two gallows erected there.

Built in 1817, with grounds including the old gallows green, Maryhill House was extensively altered with elaborate ornamental additions in 1866. By the twentieth century its proximity to the hospital made it an ideal nurses' home.

In 1947 workmen unearthed bones of a woman and child that had lain in the grounds for over a century.

Maryhill House.

A year later, in 1948, a double tragedy occurred in the grounds when it was being converted into a maternity hospital. The bodies of a young nurse and her ex-fiancé, a demobilised sergeant, were found behind the house. The soldier had been evacuated at Dunkirk and served in several other major theatres of war and his tendency to drink had resulted in the breakdown of their engagement. His final attempt to make amends, following an evening of drinking, had resulted in the tragedy when he used a German pistol to shoot firstly the nurse and then himself.

In 1950 Maryhill had been converted to a maternity hospital, with some accommodation remaining for nurses. The hospital closed in 1987 and, after some refurbishment, the building became administration offices for Grampian Health board.

In the grounds next to the house, Maryhill Health Centre is the busiest in the country with seventy staff looking after 17,000 patients.

Mills

The waters of the River Lossie were once harnessed by several mills along its route through the town. In medieval times people were forbidden to grind their own meal and corn so were obliged to take it to a mill and pay for the privilege. Mills such as Kingsmill and Bishopsmill were a good source of income for kings and for the Church.

After 1818 people were allowed to grind their own and the Earl of Fife was given £635 in compensation for loss of 'multure'.

Bishop's mill was established in 1189 after William the Lion gave the Bishop of Moray the right to build a mill below the castle. It was burnt down in 1645 by the army of Montrose.

The Deanshaugh mill had originally been a lint mill before becoming a snuff mill, a meal and barley mill and finally a sawmill.

Lossiebank mill, owned by Reid and Welsh, was opened as a tweed mill in 1884 and closed in 1980. It was converted into a garden centre and hardware shop and a neighbouring grain mill was converted into a motor museum.

Morriston

Originally Church land, the named changed from Middlehaugh to Moraystoun around 1406. The land was bought by the Earl of Fife at the time of land improvements and in 1764 all small tenants were removed and the estate was made into one large farm. A dairy farm was worked by a descendant of a McDonald who had escaped the Glencoe massacre of 1692.

A shallow ford, then later a wooden footbridge, crossed the Lossie, the Bow Brig giving access when the river was in spate. In the 1800s the farm was absorbed by Oldmills and land enclosed by substantial stone dykes.

By the early twentieth century a school had been built at Bishopmill and a few years later a council housing scheme began. By the 1960s most of the estate had been built upon by council and private housing and the Elgin Academy was built on the site of the former Morriston House in 1967.

Moss Street

Originally named Moise or Moss Wynd, it led down to the Moss of Strathcant, which was then an undrained bog between Elgin and New Elgin, the remnant of an ancient loch.

Built in 1858, the church at the top of Moss Street united with the South Street church in 1938, after which it was abandoned as a church, used as a church hall, and then as a British Restaurant during the Second World War.

Decommissioned church, Moss Street.

In 1953 during a wild January gale, a 4-ton pinnacle was wrenched from the tower and fell through the roof of an adjoining bakery. The tower was lowered and a pole erected to indicate the original height. The building is now a restaurant.

Motor Museum

This museum, opened in 1988, has a comprehensive collection of veteran, vintage and classic cars and motorbikes. The collection, near the Cooper Park, is based in a building, part of which was the old grain mill building.

In the near vicinity, the old tweed mill on the riverbank has been converted into a garden centre and hardware shop.

Muckle Cross

There was a cross as early as 1365 in the marketplace surrounding the church, a little to the west of the present cross. The present structure is a replica of one built around 1630 which fell into disrepair and was demolished in 1792. The lion rampart was

The Muckle Cross.

saved and replaced in a later major restoration in 1887. This ancient lion rampart was replaced for the millennium and the original was placed in Elgin museum.

The Muckle Cross has long been used as a platform for public proclamations, speeches and ceremonies – Lloyd George addressed a crowd of 2,000in 1925 on his way from Inverness to Aberdeen.

Museum

In 1836 a group of gentlemen formed the Elgin and Morayshire Scientific Association, eventually renamed the Moray Society, which now runs the museum. A small exhibition of articles was originally kept in a small room in the Tolbooth before the nucleus of the museum was housed in a room in the High Street. The present Italianate building was completed in 1842 at No. 1 High Street.

Funds for the new building were insufficient and the gentlemen had to ask their womenfolk for help. The ladies ran a successful bazaar, organising the town band, inviting important guests including the son and daughter-in-law of the Duke of Wellington. The outstanding debt was paid off and by 1896 an extension was necessary to house the growing collections and the hall was added in 1921.

No. 1 High Street – Elgin Museum.

A registered charity, Elgin Museum is one of the oldest public museums in the country and houses a world-famous collection of local fossils and geological specimens, as well as a wealth of artefacts spanning the centuries. The collection, including Neolithic items, Pictish carvings, Roman coins and jewellery, Elgin silver and industrial artefacts, provides a comprehensive and fascinating insight into the history of the area.

The museum has always relied on the work of volunteers and on donations to help to pay the bills and keep it functioning. Entry is free and welcoming. Thanks to generations of enthusiasts, it hosts a variety of activities, remains an independent fount of knowledge, safeguards the local heritage and provides hours of fascinating discoveries.

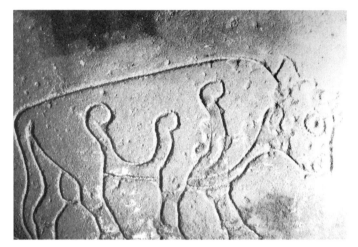

Left: Pictish carving from the fort at Burghead, now in Elgin Museum.

Below: Remembrance Sunday in Elgin Museum, 2018.

N

New Elgin

Lying beyond the railway line to the south of the town, the village of New Elgin has grown enormously over recent years. The original village was built in the early nineteenth century on land, the Muir of Elgin, acquired by the Convenery of the Incorporated Trades in 1760.

Railway construction in the 1840s–50s meant an increase in workers living in the village. The village was known as the 'Free State' because it lay in the County of Moray – the railway and open fields with grazing cows separating the village from the town burgh with its higher rates.

Wide streets were laid out, gas was introduced in 1861 and by 1879 the houses were reported as being tolerably good 'but occupied, with few exceptions, by the humble classes'.

Work was available at a flour and meal mill at Linkwood, the distillery and the sawmills. Animals were kept on the small crofts, cows supplying milk to neighbours and to the local dairy.

The Mart, which opened in 1880, had sales of pigs on Monday, cattle and sheep on Fridays and animals would be driven through the streets to the slaughterhouse at Borough Briggs. As late as 1960 pigs were still kept by some residents, much to the alarm of the sanitary inspector.

There was a small fever hospital and New Elgin primary school was built in 1905, replacing the original school, which was bought by the community and is still run as the community hall. As the population increased, the High School opened in 1978.

By 1967 there were over 400 council houses in the village, with plans for more housing and industrial developments, and it was decided to extend the official Elgin town boundary to include New Elgin. Expansion continues, and farmers' fields are now covered with new housing schemes stretching ever further south.

Newmarket

Newmarket was built in 1851, finally enabling the fishwives to sell their wares undercover.

Mask of Bacchus above South Street entrance to Newmarket.

By 1914, above the entrance forming part of the first-floor drapers was the concert hall while over the other part of the market was the Corn Market Hall, which was used as a drill hall for the local volunteer companies. The double-arched High Street entrance is now blocked up but bears an information plaque.

A grand arched entrance on South Street, decorated with a mask of Bacchus, once led through to the High Street.

Newmill

Between 1855 and 1922 the iron foundry and works based at Newmill was considered the most important public works in the county and employed up to 2,000 people. Consisting of several buildings required for the manufacture of iron, forging and engineering work, the foundry was initially established for repairing the machinery of the adjacent Johnstons cloth mill. It soon expanded to repair farm machinery, steam engines and distillery equipment. The building has undergone alterations since the 1990s after the foundry closed, and remains part of the wool mill complex, but some drain covers around the town can still be found with the Newmill manufacturers stamp.

Newmill drain cover.

Newton

In 1931 the Forestry Commission bought land at Home Farm of Newton just outside the town, for the research and supply of planting stock of trees. The 85 acres of seedbeds include native Scots pine, hybrid larch and Lodgepole pine. The research undertaken has helped define the most suitable specimens for different sites in a challenging environment, including the Northern and Western Isles, and has concentrated on environmental and biodiversity issues. It produces around seven million trees for restocking every year.

Nursing Pioneer

Born at Spynie Farm in 1857, Ethel Gordon Manson (1857–1947) created the profession of nursing as we know it today and was one of the great reformers of her time.

While her contemporary Florence Nightingale believed ladies were simply carers for the sick and dying, Ethel had other ideas. Having gained experience in hospital nursing, she became the youngest matron of St Bartholomew's Hospital, London, at a time when great advances were occurring in medicine and she believed nurses should be intelligent, skilled, and properly qualified professionals.

As was the custom, she had to give up nursing when she married, but as Mrs Bedford Fenwick she continued to devote her life to making nursing a recognised and respected profession.

The difficult battle for registration took many years, during which time Ethel also helped found the British Nurses Association and set up an International Council of Nurses. She was awarded medals for her work organising teams of nurses in the Greek-Turkish Wars.

Ethel was a suffragist as well as a journalist and nursing reformer. After many years of battling, she finally achieved the creation of a trained nurses' register in 1902. Today all nurses must train to the high standards required before they can achieve registration.

Daughter of an Elgin farmer, Ethel Bedford Fenwick is the world's first registered nurse.

Nursing pioneer Ethel Bedford Fenwick.

Oakwood

The main road runs through the Oakwood, which now consists mainly of beech trees. The Oakwood Motel was originally built here in 1932 and was a popular venue for afternoon teas and functions. The chalets and petrol pumps have now been demolished. The building has been extended and is now used for retail purposes.

The Oakwood motel building.

Order Pot

The River Lossie ran in the hollow in this area, to the east of the town, until it changed course, leaving the deep, reputedly bottomless, pool known as the Order, or Ordeal Pot. Witches were punished in Elgin up until 1736 and this pool was used for testing or drowning them. If the accused sank, she was considered innocent (although she might drown!). If she floated, she was deemed guilty and was then strangled and burned at the stake at West Port – a fate suffered by Barbara Innes and Mary Collie in 1662.

Rubble and rubbish from the ruins of the cathedral were dumped into the pool over the years by the curator, John Shanks. By 1881 the remaining water was 10 feet deep, stagnant and hazardous and the pool was completely filled in. Nothing is now left of the Order Pot apart from the commemorative stone near the site in the area of the Tyock industrial estate, beside the main road to Aberdeen.

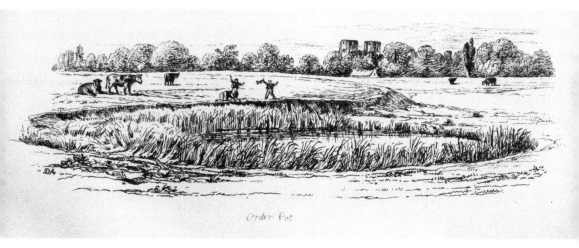

Above: The Order Pot in 1838.

Right: The Order Pot memorial stone.

Pansport

This ancient gateway was restored in 1857. The name is derived from the 'pannis', the meadowland that it overlooked when, in 1224, it was divided into crofts and assigned as glebes to the canons of the cathedral.

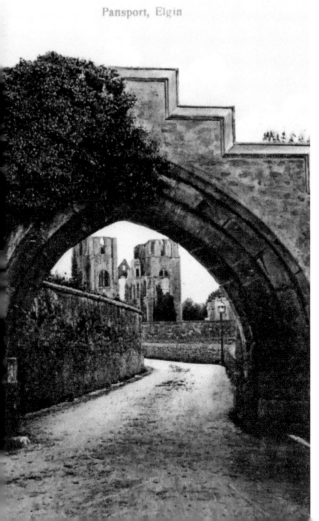

Pansport, Elgin

An old postcard of Pansport.

The 'Port' was the eastern gate to the town, also called the 'water yett (gate)', defended by a portcullis and massive wooden doors. The grooves of the old iron portcullis are still visible.

Pictish Stones

The Picts were a nation of warriors and artists who hunted, farmed and defended their territory in the east part of northern Britain between AD 300 and 1000 and were given their name by the Romans. The symbol stones with carvings of animal birds and fish remain a tantalizing and enigmatic glimpse into their world and there are many fine examples in Elgin Museum.

A beautiful Pictish carved stone from the ninth century is on display in the cathedral grounds. Known as the 'Elgin Pillar', it was unearthed a little to the north of St Giles Church in 1823, possibly having been reused as a burial slab in the graveyard there. As well as Pictish symbols, it displays a cross symbol, a hunting scene and birds of prey.

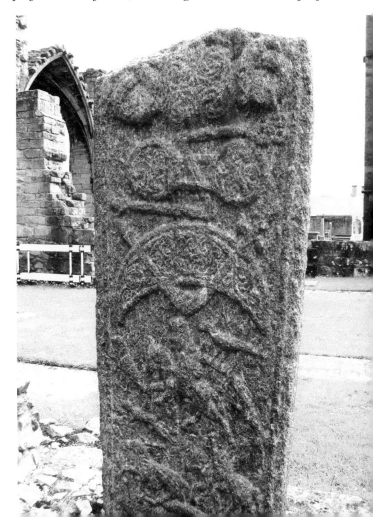

The 'Elgin Pillar'.

Pinefield

In the mid-nineteenth century George Morrison began a nursey garden on lands that had once belonged to the leper hospital. By the beginning of the Second World War Pinefield had been converted into an army training camp with barracks and a large parade ground.

Thousands of troops, including those from the Commonwealth, passed through Pinefield and houses were built as married quarters for the staff.

Many liaisons occurred between local girls and the soldiers. Some resulted in marriage and one in murder, when, in 1941, seventeen-year-old Elma Shaw was found murdered near Pitgaveny farm.

A number of units were housed here after the war until the Royal Scots finally left Pinefield barracks in 1958. Navy personnel from RNAS Lossiemouth were then housed in the former army married quarters.

Nowadays an industrial estate occupies the area of the parade ground, with housing developments nearby.

Plainstones

For centuries this area in front of St Giles Church was a focus of public gatherings, markets public punishments and a burial ground.

In the Middle Ages there was a booth where goods were weighed to assess the toll to be levied. That building became a place where defaulters and debtors were confined – more serious criminals were confined in the castle.

In 1605 the old wooden and thatched building was replaced by a more substantial Tolbooth building, which included a council room and a grim prison house.

Executions took place from the Tolbooth. Prisoners were fettered to an iron bar, which is now displayed in Elgin Museum, as is the clock mechanism, two carved stones from above the old Tolbooth door and the Tolbooth bell. The tolling of this bell was rung when trading was permitted and on any important occasion.

The building was burned in 1700 by one demented Robert Gibson, a new Tolbooth was completed in 1715, improvements made and a clock added a few years later. The Tolbooth was removed in 1843 and a fountain is now on the site.

The practice of holding a market in church graveyards was abolished in 1692 but fishwives continued to sell their wares there. Feeing markets, when farm labourers were hired, still took place on the Plainstones until the early twentieth century.

During roadworks in 1823 a ninth-century Pictish cross slab was discovered in the area of the graveyard being reused as a grave slab. Known as the 'Elgin Pillar', it is now on display in the cathedral grounds.

A touring German tank was placed on the Plainstones in 1918 in order to raise funds for the war. War Bonds and War Savings certificates were purchased through a small hatch in the side and the final total raised here was £171,000.

Above left: The Tolbooth bell.

Above right: The old Tolbooth.

Right: The Plainstones today.

The Plainstones were raised in height in 1953 and, prior to reconstruction work, archaeologists uncovered numerous skeletons from the old graveyard.

In 1996 the centre of town was pedestrianised, cobbles were laid by an Italian firm, and a mosaic and bronze sculpture placed at one end.

Police Station

Originally in Greyfriars Street from the middle of the nineteenth century, the police station was demolished in 1965 and replaced by a car park. A prison was built behind

Elgin Police Station.

the police station and the courthouse in 1842 but this was closed in 1888. The present police headquarters were built on the site of the old Town Hall and opened in 1963.

Ports

There were four entrance gates, called ports, to the town where tolls were collected and where limbs of executed criminals were put on view. During times of plague the south and north gates were closed with turf – 'biggin ye wynds'.

West Port was opposite Ladyhill and was controversially pulled down in 1783 to make way for property improvements. South Port, Smiddy or School Port, was at the south end of Commerce Street. East Port stood near the Bede houses and North Port was in the middle of Lossie Wynd. All were removed at the end of the eighteenth century.

Provost's House

The post of Lord Provost was abolished in 1975 but the two splendid lamps with stained-glass replicas of the city's arms can still be seen in the garden of what was once the Provost's house, opposite Maryhill. The first recorded Provost of Elgin was Thomas Wiseman in 1261.

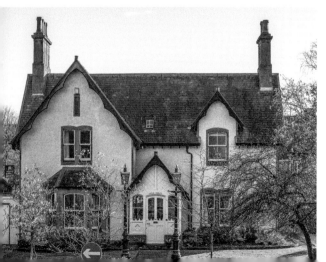

Provost's house with lamps.

Q

Quarry Wood/Quarrelwood

The main road to Inverness runs through a deciduous woodland called the Oakwood (despite now mainly consisting of beech trees). The area that rises behind, stretching northwards, is Quarrywood and is the site of a 2,000-year-old henge, possibly a ceremonial site. There was once an old castle here, but no trace of it now exists. The ancient name of Quarrelwood could be linked to archery – a quarrel being a type of arrow.

There are several old sandstone quarries within the wood, in the area known as Cutties Hillock, which once supplied millstones and most of the stone used for buildings in Elgin.

The sandstone here was formed millions of years ago in desert conditions near the South Pole and at one point lay close to the Equator before forces of plate tectonics moved what is now Scotland to its present position. Fossils and tracks of animals older than dinosaurs were preserved in the layers of sandstone. Their footprints can be seen in the world-famous Elgin museum collection along with a life-sized reconstruction of one of these animals, *Elginia Mirabilis.*

The Quarrelwood Woodland Park Association was formed in 1995 to promote the wood for the benefit of the local community.

R

Railways

At the height of the railway boom Elgin had two railway stations, being served originally by the short-lived Morayshire Railway, the Highland Railway and the Great North of Scotland Railway. Sadly, passengers can no longer take the train for a trip to Lossiemouth and other coastal villages or travel down the Speyside line.

The GNSR Elgin East station was rebuilt 1898 in Scottish Baronial style but business offices now occupy the grand building.

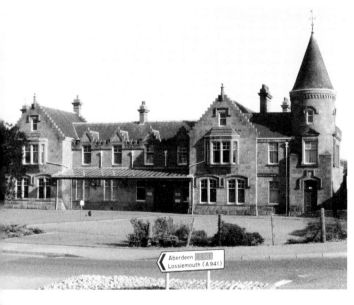

The Great North of Scotland Railway building.

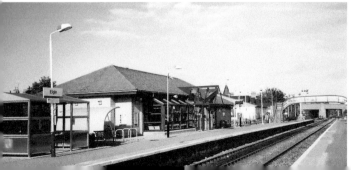

Elgin railway station before the replacement modern footbridge and lifts.

The Highland passenger station was replaced in 1990 with two platforms linked by a footbridge, later replaced by a footbridge with accessible lifts. The Elgin signal box, the most northerly manually operated by the level crossing, was demolished in 2018.

Rock 'n Roll

The first rock 'n roll event in Elgin took place in November 1956 in Bishopmill Hall when Eddie Watson and the Alligators played a fundraising dance for Elgin Football Club.

Now no longer a dance venue, the Red Shoes ballroom, opposite the present council headquarters car park, was a favourite gathering place for young folk in the 1960s, where they could dance to the latest popular music.

In November 1963 The Beatles were due to perform in Keith and Aberdeen, but due to a blizzard ended up playing in The Red Shoes, giving their first performance of 'Love Me Do'. Diners in the adjoining restaurant complained to the owner, Albert Benici, about the noise. Albert approached John Lennon and asked for a quick word. Lennon replied 'velocity'.

Romans

Proof that the Romans visited this area has been found in several places. One of two hoards containing hundreds of Roman silver coins, *denarii*, unearthed from an Iron Age site at nearby Birnie, can be seen in Elgin Museum. Also on display are delicate items of Roman jewellery and other Roman artefacts.

The Red Shoes dance hall.

St Giles

The seventh-century patron saint of Elgin, St Giles, was Greek by birth. Many miracles are attributed to him and he is usually depicted sheltering a hind from hunters, with an arrow which had been meant for the animal piercing his hand. Many churches dedicated to him were originally placed on the outskirts of towns, affording shelter to poor and exhausted travellers.

The original church was built on the outskirts of Elgin because the castle was then the town centre. It was heather thatched, and was built forty years before the cathedral and later, along with the cathedral, was burnt by the Wolf of Badenoch in 1390.

After rebuilding, the 'Muckle Kirk' underwent various alterations over the centuries and the interior could hold 2,000 people. The early burial ground surrounding the church was used as a gathering place and market in medieval times. Burials were discontinued in the mid-seventeenth century.

Because of decayed woodwork, the roof fell in and destroyed the nave one Sunday in June 1679. The building was repaired and in 1700 the north and south aisles were removed in order to widen the street. By 1826 the building was considered too unsafe and was levelled to the ground. Many remains were discovered, inside and outside the church. Some were transferred to the cathedral grounds, others carted off to be used as top dressing on nearby pastures. Many old flagstones covering graves were used as paving slabs on the High Street.

Looking west to St Giles.

The foundation stone for the new building was laid in 1827 and the church was built in the Greek Revival style, the 112-foot-high square tower ostentatiously topped with a model of the Choragic monument of Lysicrates in Athens.

Spynie

The loch of Spynie once connected with the sea and was then over 5 miles long. There is evidence of prehistoric occupation on the ancient shoreline. There was a salt extraction industry, mentioned in a thirteenth-century document, on the shore at what is now Salterhill.

Before the cathedral was built, the bishop's seat had moved from Kinneddar to Spynie for a short while.

The Elgin town harbour was once at Spynie, and ships would moor beneath the Bishop's Palace, the grandest bishop's building in Scotland. James II, James IV and Mary, Queen of Scots all stayed here at different times. The palace ruins are now in the care of Historic Scotland.

Shifting sands and tides silted up the mouth of the loch and the sea access disappeared. By the eighteenth century the loch was gradually drained by a canal system and had become a freshwater loch with the new land used for farming.

Today the main road runs across the area and the abandoned railway line is enjoyed by walkers. The remnant of the loch, once used for wildfowling by the Pitgaveny lairds, is now a bird sanctuary, the only shooting now being done by photographers.

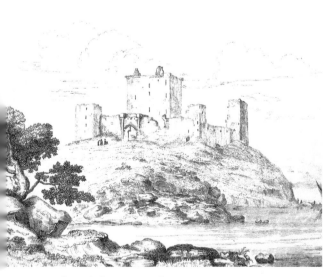

Above left: Spynie Palace, *c.* 1839.

Above right: Spynie Palace before restoration.

Above left: Spynie loch bird reserve.

Above right: Old Spynie churchyard and Spynie House.

Following the decline of the palace, in 1735 Spynie parish church moved to Quarrywood, traces of the old church barely visible in the old graveyard where the ashes of Ramsey MacDonald are interred.

Stone Balls

Almost unique to this area, these Neolithic, intricately carved stone balls remain an enigma. Despite many and various theories, no one knows their function and, displayed in Elgin Museum, they remain an unsolved mystery from more than 4,000 years ago.

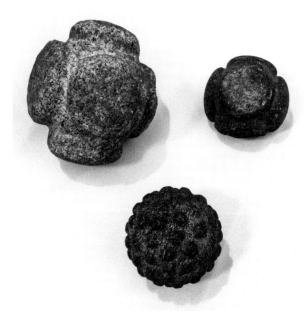

The mysterious Neolithic stones.

Stonecross

Edward I came this way in 1296. Pilgrims on their journey north would enjoy their first glimpse of the great cathedral from this slight hill, which was once marked by a stone cross.

Sellar, Patrick

In 1798, at a time of great agricultural reform, Patrick Sellar's father was on the committee of the newly formed Morayshire Farmers Club. Patrick eventually became factor of the Sutherland estates during the infamous Highland Clearances. Despite attempts to clear his name, he became a much-reviled figure because of the cruelty he employed in carrying out evictions. He is buried in the cathedral grounds.

Shanks, John

Born 1758, John Shanks was a shoemaker who lived opposite the Muckle Cross and in 1824, when he was sixty-six years old, he was employed as keeper of the cathedral ruins. The tumble of ruins had been used as a quarry for local buildings but John Shanks began to clear the chaos. In seventeen years, he removed nearly 3,000 barrows full of rubble, revealing the original shapes of tombs, carvings and ornaments of the great building.

He emptied the rubbish and stones into the Order Pot, a remnant of the old course of the river, but by then a stagnant pool. His work gradually aroused interest when more of the ancient building was revealed and people came to help remove the accumulated debris.

He was a convivial soul and he was reported one evening, along with his drinking companions, to have spent some considerable effort in trying to straighten what appeared to them a dangerously tilted St Giles Church!

John Shanks was not gifted with good looks. He was described as being skinny, round shouldered and with knock knees. He wore stout shoes, blue hose and knee britches, adorning his head with a thick-striped cap which ended in a large red tassel. He died in 1841, public subscriptions having made his final years more comfortable, and he is buried in the cathedral grounds.

South Street

Once called Back Street, with several inns and stables, this street has been in existence since the fourteenth century.

Technical College

Part of the University of the Highlands and Islands, the technology centre in Linkwood road offers a large range of courses including engineering, joinery, electrical installation mechanical engineering and plumbing.

Thunderton House

The much-altered present building dates back to the sixteenth century but around 1300 a manor house was here, surrounded by a large garden running to Ladyhill, with orchards and a bowling green. After the castle became ruinous, it was the royal residence and known as the 'Great Lodging' and also the 'Kings House', and used by the Earls of Moray.

The Sutherlands of Duffus acquired the property in 1650 and additions were made, including the 'savages' or stone statues. Carved around 1600, these once stood at the door of Thunderton House, supporting the Duffus coat of arms and were probably brightly painted.

Elgin Technical College.

When the Dunbar family acquired the property, it was renamed Thunderton House. In 1746 it was occupied by Lady Arradoul, a fervent Jacobite who was hostess to Prince Charles Edward Stuart days before the Battle of Culloden. She is buried in the bedsheet he used and his ghost is reputed to haunt the building.

In 1800 John Batchen, auctioneer, purchased the house, let the lower part as a preaching station and erected a windmill on the bartizan tower. A succession of businesses, including a temperance hotel, a printing works, furniture warehouse, masonic lodge, and aerated water factory, occupied the building before it become a hotel. It is presently undergoing refurbishment.

Stone 'savages' from Thunderton House.

Thunderton House.

Tower

One of the oldest buildings in the town, believed to once belong to the Knights of Hospitalers of St John in the thirteenth century. The tower stair is the only part remaining of the old building, which was altered in 1634.

Later it was owned by bookseller Isaac Forsyth who, from 1789, ran the first circulating library in the north of Scotland. The building was remodelled but the tower remains and the property has housed a temperance hotel, various offices and latterly a shoe shop.

Town Drummer

At a time when ordinary folk had no clocks, the Town Drummer went up and down the Closes at 4 a.m. then again at 5 a.m. to rouse folk for work. He also drummed at times of curfew or for major announcements. The last town drummer died in 1906 and the drum can be seen in Elgin Museum.

The bronze statue near the Muckle Cross commemorates the Town Drummer, particularly one called William Edward who did the job for fifty years, from 1760 until 1822.

Below left: The Tower.

Below right: Statue of the town drummer.

Town Hall

The splendidly ornate Town Hall on Academy Street, containing an 80-foot corridor and large hall seating 1,000 and a smaller hall, as well as caretaker's apartments, was opened in 1885. Suffragette Mrs Pankhurst gave a speech to a full hall there in Sept 1910.

In December 1939 when soldiers were billeted there, the building was reduced to ashes, some thought due to a discarded cigarette, but others blamed faulty electrical wiring. Today the police station occupies the site.

The less ornate but more practical new Town Hall was opened in December 1961 and is well used for exhibitions, concerts, lectures, conferences and dances.

Right: The old Town Hall, Moray Street.

Below: Today's Town Hall, Trinity Place.

University of the Highlands and Islands

In 2011 Moray College became one of thirteen campuses and research institutions across the Highlands and Islands with full university status, catering for full-time and part-time students, offering degree and postgraduate courses.

The award-winning extension, the Alexander Graham Bell Centre, includes a simulated ward for training nurses as well as containing conference facilities and classrooms. A popular and excellent restaurant, the Beech Tree, is open to the public and staffed by the catering students.

As well as the large main Elgin campus there are learning centres in Buckie and Forres and the Technology Centre campus based in New Elgin.

The University of the Highlands and Islands, Moray College.

Urquhart Hoard

There was once a priory at Urquhart, just outside Elgin, founded in 1125 and occupied by Benedictine monks. It fell into disuse, was abandoned in 1454, and the building plundered for stone.

In 1857 a hoard of over thirty-six Iron Age gold armlets or torcs were unearthed here by a ploughman. Known as the Wall Hoard, after the farm where it was all found, initially some of the objects were not recognised as valuable and were lost or discarded. Seven of these torcs, dating from 200 BC, are in the British Museum – one is in Elgin Museum.

Gold torc, part of the Urquhart hoard.

Victoria School of Art

With origins in the Elgin Drawing School, this developed into the Elgin School of Art with a room in Johnstons factory, later moving into the supper room of the old Town Hall.

The present building was opened in 1891, having been built as a memorial to Queen Victoria's Golden Jubilee. The school provided technical instruction in art, basic science and engineering. It was later used by the Academy and remains part of the university campus.

Victoria, Queen

In September 1872 Queen Victoria passed through Elgin in her train on her way to Dunrobin from Balmoral. Platform tickets for this auspicious occasion ranged from 6d to 2/6 per person and the station was crowded. The train stopped at 13.58, and the door was opened by John Brown, allowing the Queen to hear the loyal speeches. The stop lasted eight minutes.

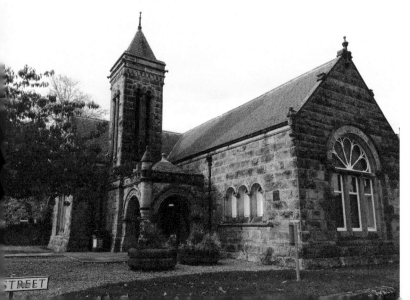

Victoria School of Art.

W

Walkers

Established in 1898 in nearby Aberlour, this family-run business exports its cakes and biscuits worldwide. A new factory was opened in New Elgin to produce its award-winning products and the firm has a popular shop on Elgin High Street.

Wards

This area beside the Tyock Burn was once grazing farmland and, despite frequent ditching, was subject to frequent flooding and unsuitable for building development. It was designated a wildlife area in the early 2000s in order to protect colonies of rare wild plants and wetland birds and insects and is now a pleasant walking area.

The Wards reserve.

War Memorials

The Seaforth Highlanders were mobilised in the first week of August 1914. The 900 men were quartered in the Drill Hall before a rousing send-off when they set off by train to Invergordon.

The war memorial on the Plainstones, dedicated to 461 men of the town and parish who died in the First World War, was unveiled in December 1921. The 12-foot-high pedestal from Greenbrae quarry, Hopeman, supports a figure holding a sword signifying victory, the torch in the left hand supported by cherubs signifying peace.

The war memorial in New Elgin was unveiled in October 1922 by two children of soldiers who had died. The figure, in full marching order with arms reversed, is of George A. Browse, Company Sergeant Major of the Seaforth Highlanders who was awarded the Military Cross for conspicuous gallantry and devotion to duty. Prior to the war he had played for both Bishopmill and Elgin football clubs.

In 1923–24 fifty-one trees were planted along the avenue leading to the New Elgin memorial and cemetery commemorating the men of the 51st Highland Division who died in the First World War.

Names of men who died in the Second World War were later inscribed on both memorials and services are held at both memorials every Remembrance Sunday.

Below left: Elgin war memorial.

Below right: New Elgin war memorial.

Water

Today the town's water supply comes from Glenlatterach reservoir, lined with stones from Gordon Castle. The dam was constructed in 1950 on a tributary of the River Lossie.

Wolf of Badenoch

Alexander Stewart (Alexander Mor Mac an Righ) was a son of King Robert II by his mistress (later second wife). He became Lord of Badenoch and Buchan, with land from the Pentland Firth to Moray and, following his political marriage to the Countess of Ross, held the Earldom of Ross. His wife had no children and he continued to consort with his mistress who bore him several children. His wife enlisted the support of the Church and, with land and property involved, a fierce quarrel ensued and Alexander was excommunicated.

A furious Alexander sent out the fiery cross in 1390 to gather his supporters. With his 'Wyld Wykkyd Heland-men' he swooped down from his stronghold of Lochindorb, burned the town of Forres and Church property there and in June he burned the town of Elgin, manses of the canons and chaplains of the cathedral along with books, charters and other valuables.

Alexander later repented, was absolved and lies in a splendid tomb in Dunkeld Cathedral.

His natural son, also Alexander, was a man of great honour, was twice a special ambassador to France and commanded forces at the deadly Battle of Harlaw in 1411.

Wolf of Badenoch statue on Trinity Road corner.

Xavier

Born in Dublin in 1872, Julia Collins entered Greyfriars Convent, Elgin, when she was seventeen years old. As Sister Xavier she eventually became head of infants at St Sylvesters, Elgin, before moving to the school at Tomintoul. Greyfriars remained her mother house until her death in 1941.

X-Rays

In the late 1990s a geologist realised the implications of a rusty-looking cavity in a block of local sandstone. Thanks to scanner X-rays and computer tomography, an image of the cavity was revealed and a model of the cause of the cavity was created. This proved to be a skull of a reptile *dicynodont*, alive between 298 and 252 million years ago, long before the dinosaurs. This model is on display in Elgin Museum.

Y

Yeadon's Bookshop

One of the oldest continuously trading bookshops in Scotland, Yeadon's was established in 1887 in Elgin by James Dawson Yeadon. Originally in the High Street, the business moved to its present building in the 1930s. James Yeadon also ran a book-binding business, lending library and printing office, publishing works of local history and interest. Prime Minister Ramsey MacDonald was a close friend.

After fifty years of work James retired in 1937. The business was purchased in 2007 by the managing director of Birlinn Ltd. The name was retained, the shop was extensively refurbished and a new branch was opened in Banchory.

Yeadon's bookshop, Commerce Street.

Zulu

The 'Zulu' was a new efficient style of fishing boat designed by William Campbell of nearby Lossiemouth in 1879, the name relating to the Zulu wars of the time. By 1900, 480 Zulus were registered in Buckie. By the time of the Second World War these once popular boats were no longer to be seen in the Moray Firth.

A scale model of a Zulu can be seen in the Elgin Museum.

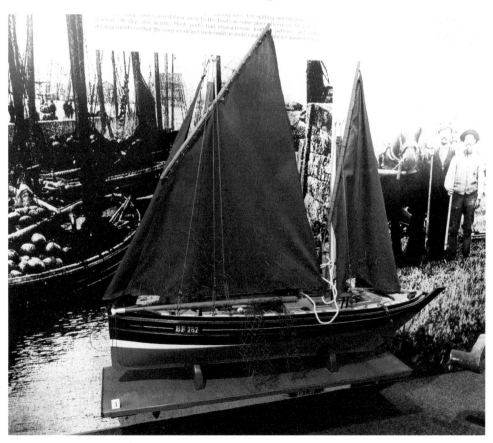

Scale model of a 'Zulu'.